*Claude Lorrain*
The Great Draughtsmen

# Claude Lorrain

Sabine Cotté

George Braziller   New York

Claude Lorrain
*Translated by Helen Sebba*

*General Editor*
Henri Scrépel

*Originally published in French under the title*
l'Univers de Claude Lorrain, *in the series* Les Carnets de Dessins.

*Copyright © 1970 by Henri Scrépel, Paris.*

The author wishes to acknowledge his debt to Marcel Röthlisberger
in *Claude Lorrain, The Paintings* (New Haven : Yale University Press, 1961).
and in *Claude Lorrain, The Drawings* (University of California Press, 1968).

Quotations from Sandrart and Baldinucci are cited
from the English translation by Marcel Röthlisberger
in his *Claude Lorrain : The Paintings* (New Haven : Yale University Press, 1961).

*Published in the U.S.A. by George Braziller, Inc., 1971.*

*For information address the publisher :*
*George Braziller, Inc.*
*One Park Avenue*
*New York, N.Y. 10016*

*Library of Congress Catalog Card Number : 76-137220*
*Standard Book Number : 8076-0594-8*
*Printed in France.*

# Claude Lorrain

## The Great Draughtsmen

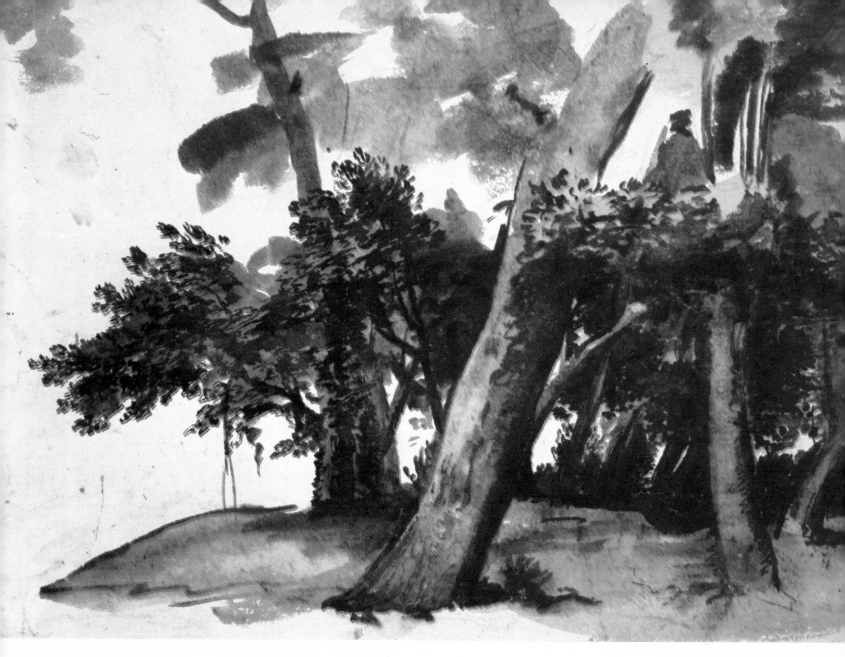

1. Wooded View (1640-1645)
   Chalk, brown wash

   Teyler Museum, Haarlem

# Contents

From the Historical Claude Gellée to the Timeless Claude Lorrain     11
Drawing : A Visual Asceticism     15

THE LIFE AND THE LEGEND     19

The Lure of Rome     22
Claude and His Patrons     25
The Mature Years     31
Claude's Contemporary Reputation     35

THE ART OF CLAUDE LORRAIN     41

The Artistic Vocabulary     45
The Radiant Void     51
Subject and Setting     55
Toward Perfect Harmony     59

DRAWING : THE SENTENCE AND THE WORD     63

The *Liber Veritatis*     66
Technique and Vision     69
The Light of "Background Worlds"     77
Dream Geometry     82
Color     86
The Heritage of Claude Lorrain     89

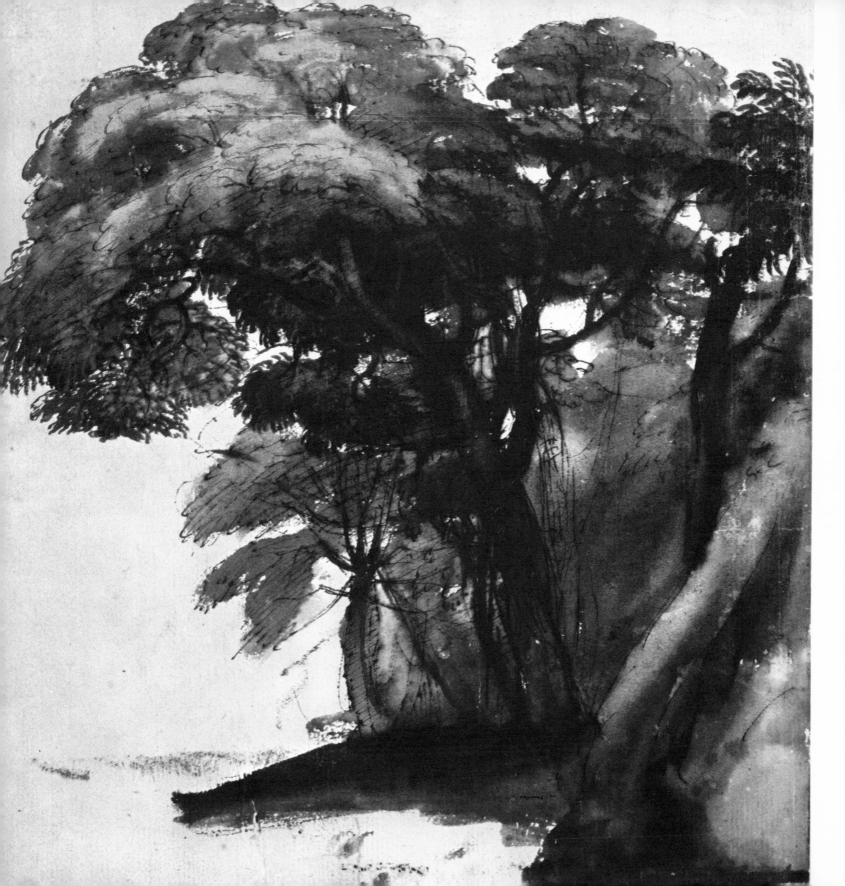

# From the Historical Gellée
# to the Timeless Lorrain

Who is Claude Gellée, otherwise known as Claude Lorrain? A question that sounds so simple must surely be ambiguous. A gap of three centuries separates us from him. Every age, every generation, has seen him in its own particular way. To avoid confusing the evidence, pursuing false trails, and distorting this master, we must state the problem more precisely: not merely, who is Claude Lorrain, but *for whom?*

What his contemporaries saw in his work is very different from our evaluation of it today. There is the seventeenth century's Lorrain, and there is the twentieth-century Claude. We shall examine both of them, for both are essential—indeed complementary. A study of Claude in the context of his time is obviously a task for the historian. Its object will be to rediscover the man in his family, social, and professional environment; understand his world and how it influenced him; investigate his sources; find out what he must have seen, thought, and felt, and what he was trying to do. These are the primary questions we shall have to confront. But if we stop there and confine ourselves to Claude in his seventeenth-century context, we overlook the essential point and forget that Claude Gellée is also Claude Lorrain, a painter whose work is timeless, whose vision has survived throughout the centuries, enriching them as it was itself enriched by the past. As with all the great masters—and perhaps this is precisely what makes them great—it is very easy to divorce Gellée's work from the artist and his time. We might even say that

2. Trees (1640-1645)
   Pen, brown wash

   British Museum, London

11

the historical Gellée has no more to teach us than the most obscure of his contemporary colleagues—and may well have less. He did not go in for writing or theories but devoted his life to painting and drawing. The reward of this single-minded passion and absolute fidelity was immortality.

But with Claude it is not merely a matter of immortality. It would be better to speak of multiple existences, constantly shifting and changing, inexhaustibly seeking new departures. Claude occupies an enviable position in the pantheon of painters. He is not one of those rigid idols or fossilized géniuses that history worships but does not dare to touch or let itself be touched by. He is relevant to every age, touches them all, and has much to say to us today. To take such a puristic view of history as to ignore this permanent dialogue and neglect these interchanges would be to slight both the painter and history itself, for they are an indispensable part of any study of Claude Lorrain.

Whereas the rediscovery of the historical Claude is useful, the rediscovery of the timeless Claude is essential. He eludes the one-eyed vision, baffles the one-track mind. His history is continuous. It did not stop at the instant of his death. It is still evolving, and tomorrow's Claude will be different from yesterday's. Indeed, it is this never-ending dialogue between his work and the sensibility of generation after generation, right up to the present, that has shaped our own view of him. What appeals to us in Claude is not merely seventeenth-century art. In the following century, the light he created already begins to acquire a new function. It lends a nostalgicg low to *fêtes galantes*. It embarks for Cytherea, returning a few decades later, wreathed in pre-Romantic mists, to invade the Roman Campagna with a proliferation of ruins, *contre-jour* effects and sharp shadows. Turner is carried away in its great clouds; its colorful fall brings to life Impressionism's shimmering brilliance. And it does all this without ever ceasing to embody the classical ideal of order, restraint, balance, and reason. This involves no contradiction but merely the multiple life of which all great works partake. Clearly, then, we must seek out the timeless Claude Lorrain just as carefully as the historical Claude Gellée. We shall try to determine what qualities in his work have earned him this immortality and why certain characteristics typical of his age have in his case transcended the age. Fortunately we have at our disposal a great body of neglected material: the drawings.

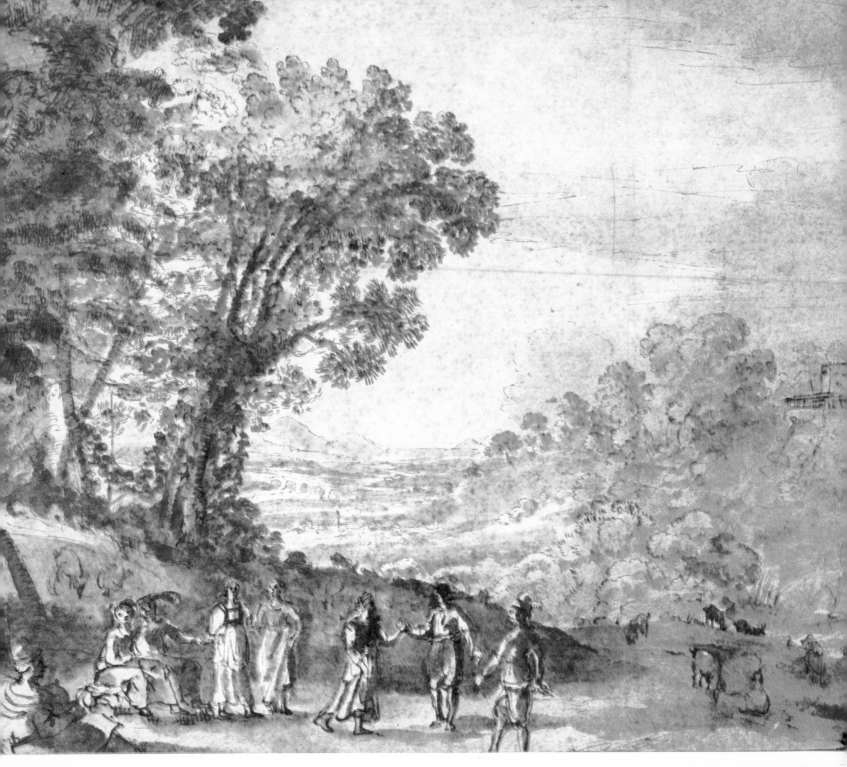

3. Landscape with Dance (1630-1635)    Pen, brown wash                    British Museum, London

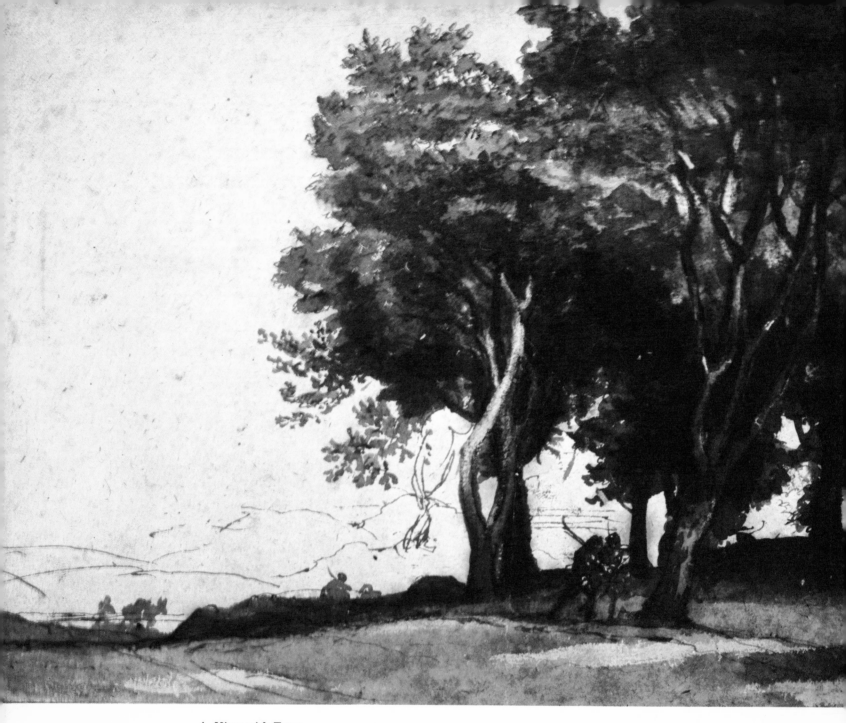

4. View with Trees
   Pen, brown wash

   Musée Condé, Chantilly

14

# Drawing: A Visual Asceticism

An artist's drawings offer incomparable insights into his *œuvre*, particularly the aspect of it that concerns us here. The paintings, as we shall see, reflect historical considerations, imperatives dictated by the time, intellectual preoccupations, the influence of aesthetic theories. Here the historical Claude is uppermost.

The drawings reveal a different man. Here we see Claude face to face with himself, confronting a blank page, glimpsed in the utmost intimacy of his working life, having closed his studio door on the bustle and demands of the daily round. Like most of his contemporaries, he did not make drawings with the idea of selling them. He did, of course, sell some, but reluctantly, as a writer might agree to the publication of a few pages from a personal diary written out of inner necessity. Since Claude never intended these drawings to be sold, they are not made for the public, and this gives them a certain purity. By essence and vocation they are monastic rather than worldly. A visual form of prayer, they represent Claude's asceticism, his retreat. Uncommissioned, free of all external pressure, his drawings reveal the fountainhead of his work in all its spontaneous purity. We shall try to discern the basic mechanisms and primary impulses that constitute the substructures, the very foundations, of his art. These substructures contain the key to Claude. It is because of them that Claude Gellée became Claude Lorrain. Through them we may come to understand how the paintings were able to transform the plastic vocabulary of their time and give the historical a dimension of eternity. The reader is invited to trace the path leading from the historical Claude Gellée to the timeless Claude Lorrain.

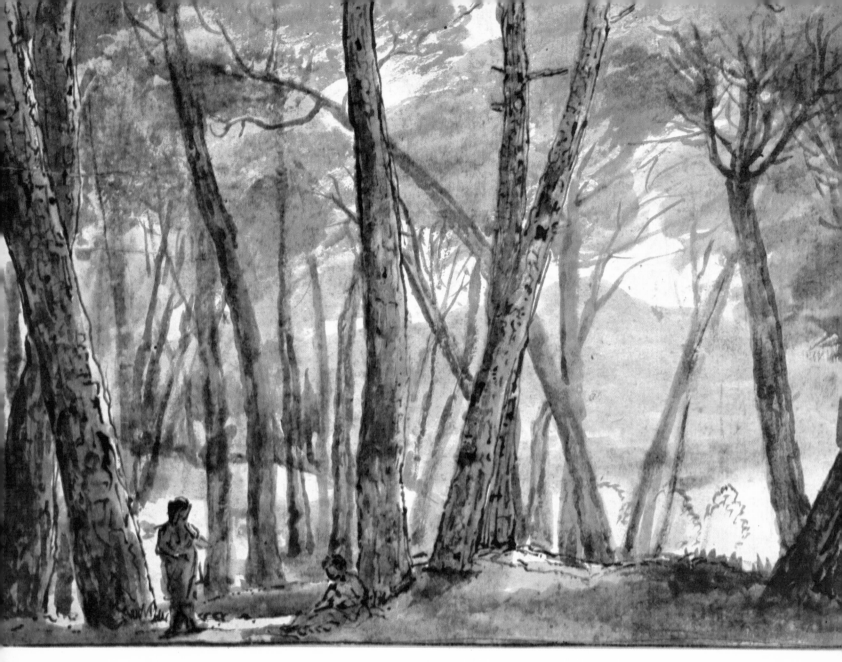

5. Pine Forest (c. 1640)
   Pen, brown wash

   Teyler Museum, Haarlem

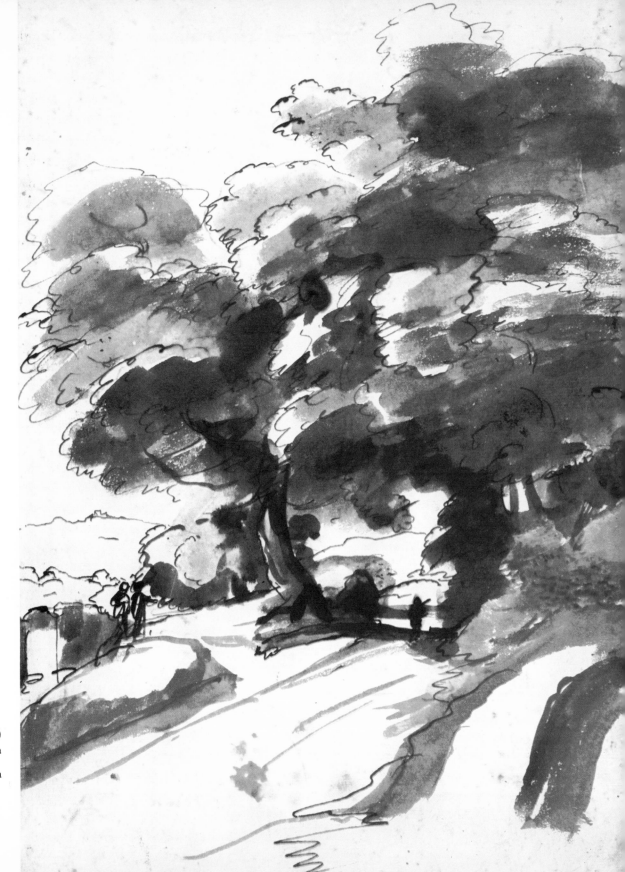

6. Landscape with Trees (1640-1645)
Pen, brown wash

British Museum, London

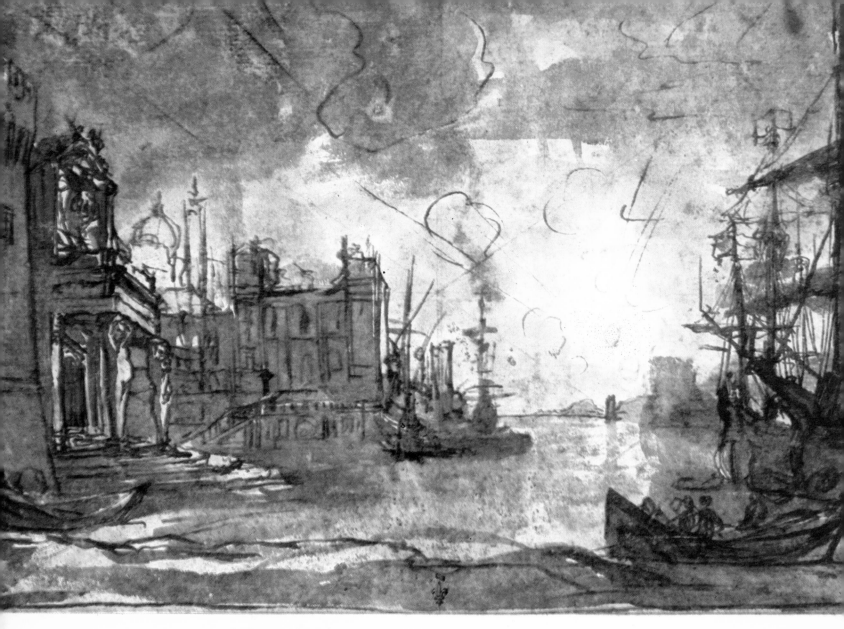

7. Seaport (1635-1640)
Pen, brown wash

Musée Condé, Chantilly

# I

# The Life and the Legend

We may begin by posing our original question: Who is Claude Lorrain? While his works live on in all their actuality, the man himself, whose life and personality offered so little scope for anecdote, seems to escape us. "In his manner of life he was no great courtier, but good-hearted and pious; he searched for no other pleasure beside his profession," says one of his intimate friends, the German painter Joachim von Sandrart, who was closely associated with Claude in Rome between 1628 and 1636. Sandrart's biography of Claude in his *Teutsche Academie*, published in Nuremberg·in 1675, is the only firsthand record of the painter that survives. Another account, Baldinucci's *Notizie de' Professori del Disegno* (Florence, 1728), is well authenticated, being based on recollections of Claude's nephews and heirs after his death. In spite of, or perhaps because of, the sketchiness of this material, later biographers fabricated a legend concerning the hardships of Claude's early days—and he may even have contributed something to it himself. The legend represents him as a poor, illiterate shepherd from Lorraine who made his way to Rome and by dint of hard work attained success and wealth. Baldinucci recognizes his talent for landscape painting but stresses his ignorance and lack of culture: "Moreover he was excessively uneducated, and it was only with great difficulty that he could sign his own name."

How much truth lies behind this legendary portrait? Claude Gellée was born at Chamagne in Lorraine in 1600 in what were without doubt modest circumstances. He was the third son in a family of five children. According to some accounts he was orphaned at an early age and did poorly in school, others say that he served an apprenticeship. This is what Sandrart tells us: "There ares trange things to tell of him. Thus, after having first learnt little or almost nothing in writing school, he was put by his parents in the service of a pastry cook. Having acquired some experience in this profession, he went, as was the professional custom, to Rome—like many others of his countrymen, for there are always several

hundred cooks and pastry cooks from Lorraine in Rome." After various vicissitudes he abandoned his original trade and went into domestic service with Agostino Tassi, a disreputable bohemian painter of landscapes and architectural subjects. Here, says Sandrart, he "would apply himself very willingly to his cooking and care for the whole household, clean everything, grind the colours for painting, and clean palette and brushes ." Did his master initiate him into the secrets of painting and drawing? It seems likely, but we have no evidence beyond what the biographers tell us.

The facts recounted by Sandrart, the friend of Claude's youth, and confirmed by Baldinucci (who adds an account of Claude's first visit to his brother in Freiburg-im-Breisgau and a visit to Naples with a little-known painter called Goffredi or Gottfried Wals) are probably correct, at least in the overall picture they present. For, although the story of Claude Lorrain's start may sound surprising, not to say romantic, to a modern reader, this impression is quickly dispelled when we look at it in the light of what we know about seventeenth-century society.

What was the social origin of the painters of that age? Most of them were sons of artisans, sometimes of artists. They were modest people who came from a class without private means. Their only prospect of improving their station was by becoming successively apprentice, journeyman, and master-craftsman. Aprenticeship was the most common means of social advancement in the seventeenth century, but since it required the payment of fees, it was restricted to children of parents in fairly comfortable circumstances. After all, if Nicolas Poussin could marry the daughter of a Roman cook when he was already a famous artist, there is nothing surprising in Claude Gellée's having started out as a pastry cook. As for his alleged lack of education, he may well have overcome it—we have proof that he knew how to write—and attained at least an average level of culture. He was self-educated rather than uneducated.

Not until 1625 does the legend surrounding his early days yield to verifiable facts. In that year he left Rome for un known reasons and returned to Lorraine by way of Venice and Bavaria. He made his real start as a painter at Nancy, where he was engaged as an assistant to Claude Deruet, a prominent artist at the court of the Dukes of Lorraine. In the early seventeenth century this little court had turned Nancy into a brilliant, sophisticated capital. Here flourished one of the last great Mannerist painters, Jacques Bellange. It was the birthplace of Jacques Callot, whose sardonic burin was to leave its mark on his century. Among the artists who worked there was Georges de la Tour, seven years older than Claude, later awarded the proud title of *peintre ordinaire du Roy*. Claude Gellée could perfectly well have established himself in his native province without risking obscurity. It seems that the idea never entered his head. He left Nancy again in 1627 and went by way of Lyons to Marseilles, where he embarked for Civitavecchia. From there he made his way back to Rome—this time to stay.

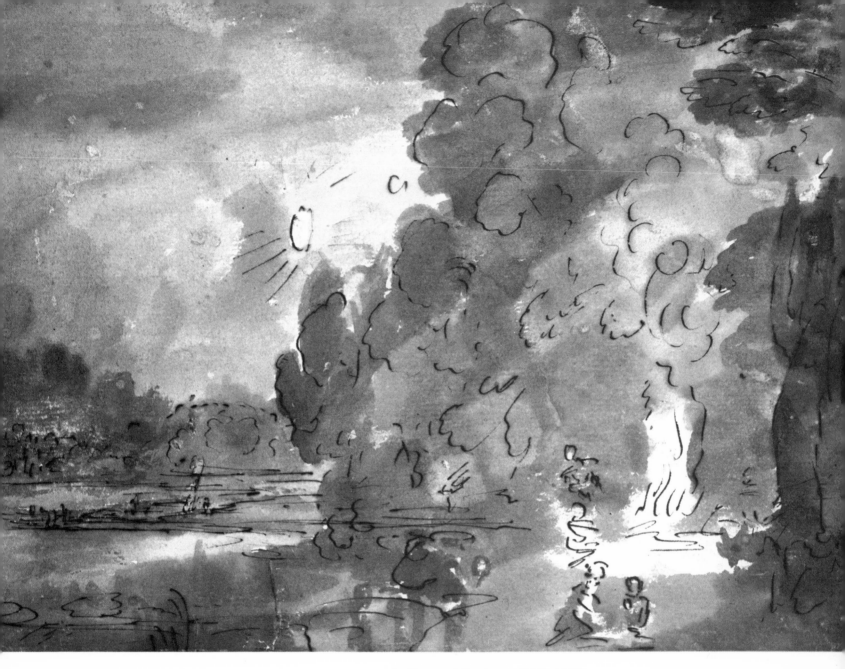

8. Nocturnal Landscape (1640-1645)
   Pen, brown and gray washes

   British Museum, London

# The Lure of Rome

Like most of the painters of his generation, Claude Gellée responded to the lure of Rome. This phenomenon, surprising as it may seem, is prevalent enough among seventeenth-century artists to warrant investigation. The small group of close contemporaries destined to become the great painters of France's classical century had remarkably similar careers. All of them felt the lure. They all went to Rome, where they were in close and friendly contact. Many of them served the same clients. Above all, they saw painting as a challenging venture that began in Rome.

We may cite some examples. Vouet was born in 1590, Valentin in 1591, Callot in 1592, Vignon in 1593, Poussin in 1594, and Claude in 1600. They all spent some time in Rome; some of them settled there permanently. What was it that drew them? They lived close to one another in the quarter between the Piazza di Spagna and the Piazza del Popolo, along what is now the Via de Babuino. Here artists from all over the world congregated, many of them from France and the Low Countries. They came to seek their fortune, as well as to learn their craft, compare styles, and renew their inspiration. They usually arrived penniless and would room together while awaiting the introduction to a bishop or cardinal that would lift them out of obscurity and poverty.

Comradeship and friendships flourished in this curious, complex milieu. Morals were free and easy; papal authority was not repressive. The taverns did a roaring trade. This medieval quarter was seething with intellectual excitement, much as Montparnasse was in the 1920's. Contact with other nationalities provoked stimulating rivalries. Discussion of masterworks of the past led to a reevaluation of more recent works such as the famous Carracci Gallery in the Palazzo Farnese or the paintings of Caravaggio. For Caravaggio still overshadowed these young artists, arousing both sincere admiration and sharp criticism.

It was in this quarter of Rome, the international art capital of the day, that Claude installed himself. His first ten years there were to be obscure and difficult. At first he shared a room with one or two Flemish or Italian colleagues. By 1634, however, he was sufficiently prosperous to engage a manservant, Giandomenico Desiderii, whom he took into his household out of charity and who remained with him until 1659. He owed this relative affluence to some commissions he had obtained about 1629 for frescoes in the palaces of certain Roman gentlemen. These were undoubtedly his first independent commissions.

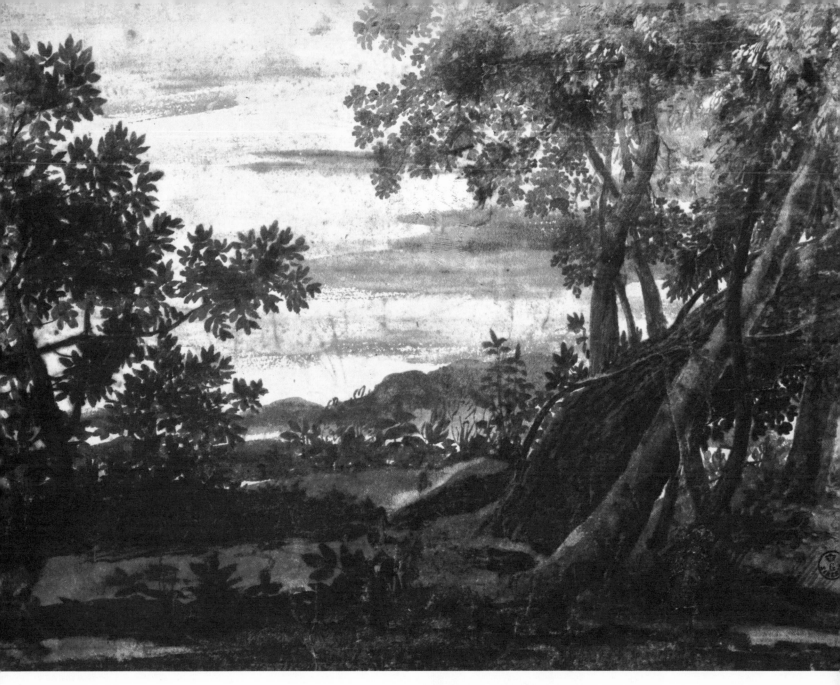

9. Wooded Landscape (1640-1645)
Brown wash

Uffizi, Florence

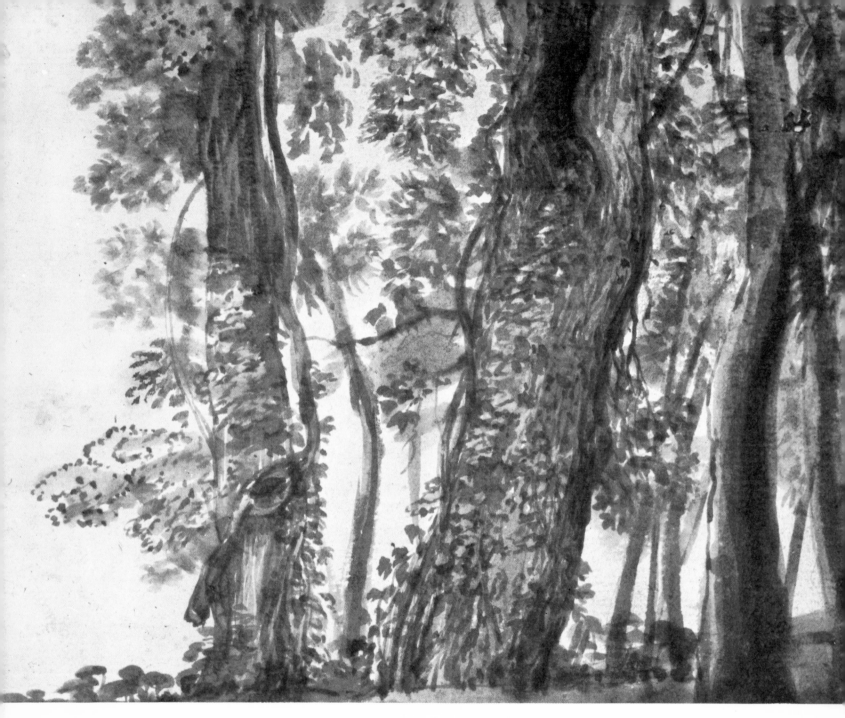

10. Wooded View (c. 1640)
   Brown wash

   Teyler Museum, Haarlem

# Claude and His Patrons

**B**ut his contemporaries, notably Sandrart, report that he devoted himself mainly to study. With Sandrart, Poussin, or some other French or Flemish colleague he would ride out into the countryside around Rome to paint from nature. "First and last he was a student of nature," says Sandrart, and he must be referring to Claude's early days, since he himself left Rome for good in 1635. Through hard work Claude acquired a perfect mastery of landscape painting. "He has made wonders and may justly be called a forerunner and surpasser of all the others." After this he devoted himself to easel painting, which was to consolidate his reputation.

Never was Roman painting so brilliant as in the first half of the seventeenth century. The colonies of artists who congregated there were one reason for this. But a new phenomenon also contributed to that period of artistic glory in the Eternal City: Rome had become the center of a regular art trade, which was attracting a very distinguished foreign clientele. The important collections of paintings that now form the core of the great European museums were established in the seventeenth century. These paintings, which were intended for the decoration of princely residences, were originally part of a permanent decor which also included frescoes, stuccowork, and carved and painted panels and whose splendor was supposed to add to the prestige of their owner and show his interest in all forms of culture. If the collector could not go to Rome to do his buying in person, he would send a representative to negotiate directly with the painter, whose popularity and prices would then soar. Such negotiations were among the duties of the ambassadors of foreign sovereigns.

Because of the remarkable development of this art trade and the growth of private collections in many different countries, Claude's clientele, once he was established in Rome, included as many foreigners as Romans. For this reason he soon gave up the decorative fresco work in which he had achieved some reputation in favor of medium-size easel paintings, which were easier to ship than bigger works. The shift to oil colors and the change of format led him to a new interpretation of landscape, and it is this new vision that constitutes the originality of his art.

Claude's principal clients included members of the powerful Barberini family, notably Pope Urban VIII himself, to whom he had been introduced by his close friend Cardinal Guido Bontivoglio. Bontivoglio's commission of a painting in 1639 marked the beginning of Claude's rise to fame and the origin of the tradition that "he gained the affection and protection of the Pope, who would often converse with him." At about the same time King Philip IV of Spain commissioned a series of landscapes as part of a grandiose decorative scheme for the Buen Retiro Palace in Madrid. After Urban VIII died, his nephews, Cardinals Francesco and Antonio Barberini, remained clients of Claude. But they soon fell into disgrace and were succeeded by other Roman noblemen from the families of later popes: the Pamphili, the Chigi, and the Rospigliosi. Prince Colonna, husband of Mazarin's niece Maria Mancini, confirmed Claude's success among the high nobility. From that time on, says Baldinucci, "the way to the acquisition of his pictures was closed forever to anyone who was not either a great prince or a great prelate or who could not procure them through the agency of one of these, at great expense, or with diligence and long patience."

In France his landscapes were bought by the country's leading dignitaries: M. de Béthune, brother of Sully and ambassador of France in Rome; the Duke of Bouillon, commander of the papal army in Rome; the Duke of Liancourt; the brilliant young Louis Henri de Loménie, Count of Brienne, whose collection was to become famous. Alongside these distinguished names stand those of art-lovers from the bourgeoisie and the *noblesse de la robe*: Maître des Comptes Passard, M. de Bretonvilliers, and other less prominent personages. His canvases were dispatched to England, Antwerp, Amsterdam, and Germany, where they graced the collection of Baron von Mayer.

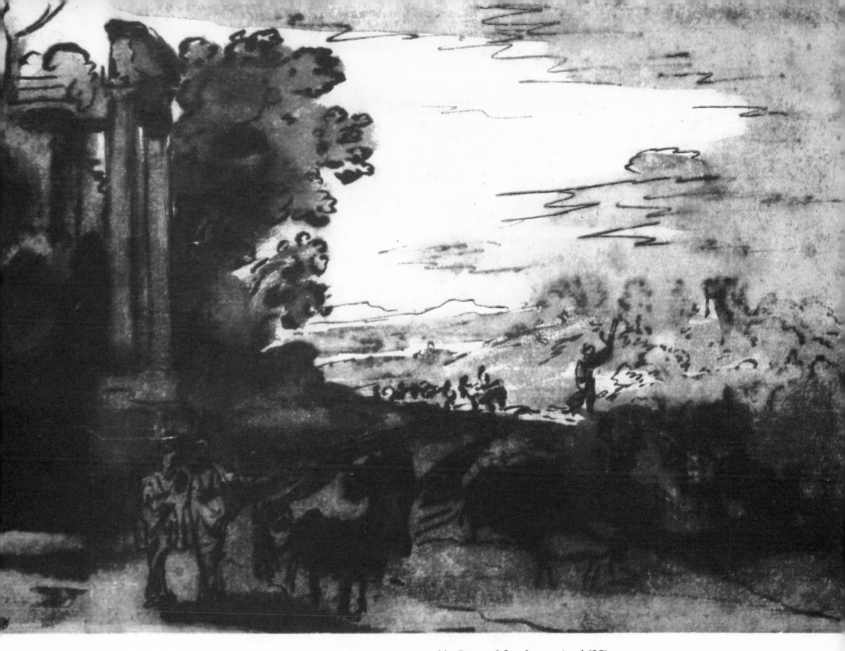

11. Pastoral Landscape (c. 1635)
Pen, brown wash

Ecole des Beaux-Arts, Paris

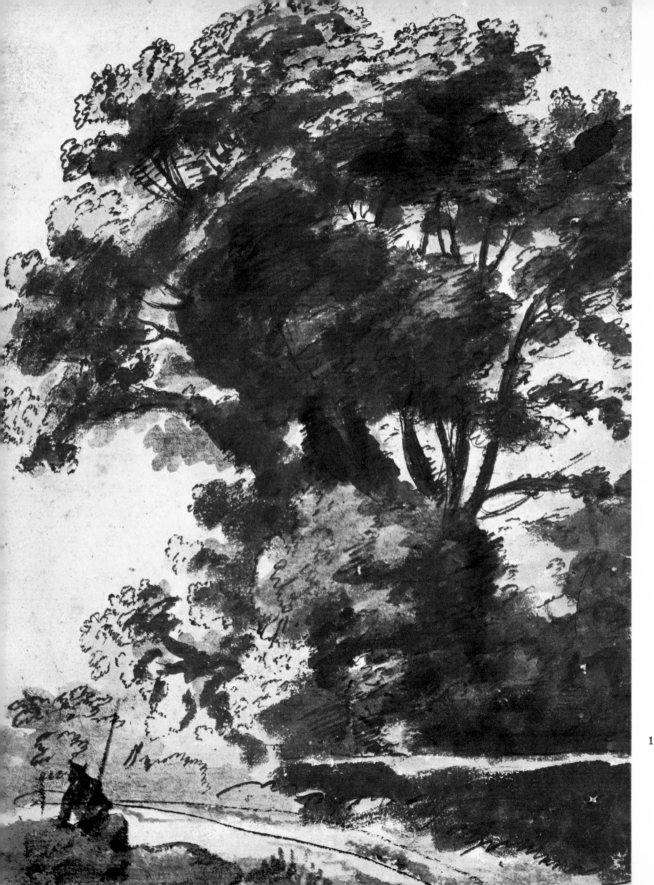

12. View with Trees (1630-1635)
Pen, brown and gray washes

Albertina, Vienna

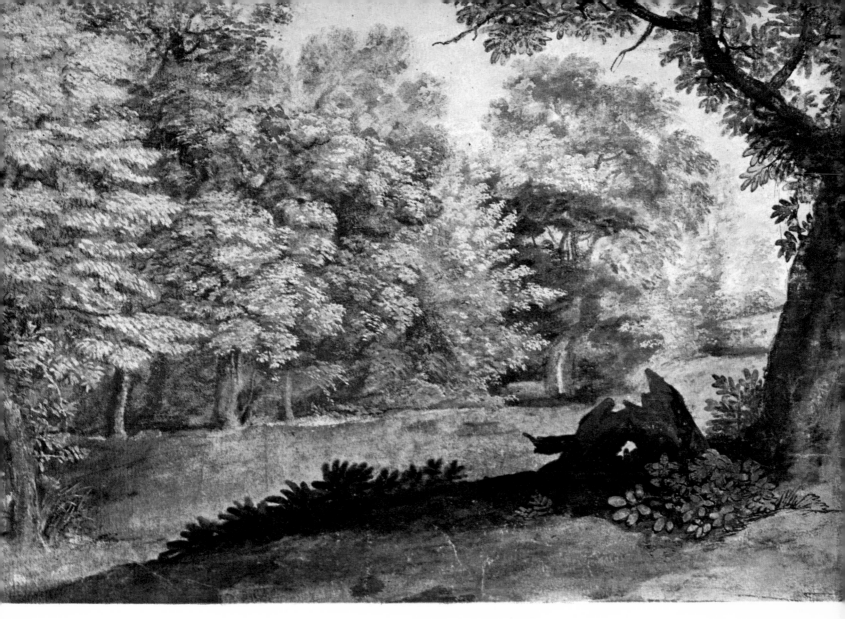

13. Wooded View (c. 1645)
    Blue paper, brown and gray washes

    British Museum, London

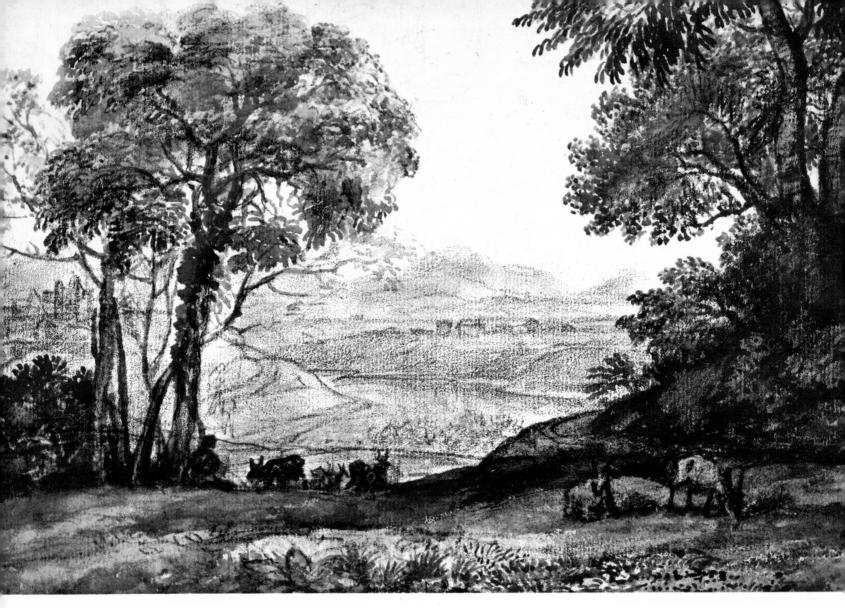

14. Landscape (c. 1650)
    Chalk, brown and grayish washes

Teyler Museum, Haarlem

# The Mature Years

Deluged with work, Claude hardly left his house anymore. In any case he was crippled with gout, having suffered his first attack at the age of forty. His growing prosperity led to a more comfortable way of life but no radical changes, for Claude stuck to his simple ways as long as he lived. He moved only once, in 1650, and then only to a neighboring street in the same quarter. According to the inventory taken after his death, his house consisted of a ground-floor room which served as a studio and four rooms on the upper floor, well furnished with dishes, silverware, linens, books, and paintings. It was by no means a palace, but it was a very comfortable residence. He lived there with two nephews, Jean and Joseph, whom, according to Sandrart, he had brought to Rome from Lorraine and who "cared for his whole household and cash, procured colors and brushes, so that he could peacefully attend solely to his studies." From 1651 on his household also included a little girl named Agnese, no doubt his natural child, whom he brought up as a daughter and remembered in his will, along with his nephews, his family, his parish, and his close friends.

Such was the uneventful course of a life dedicated entirely to work, which reached its peaceful end in 1682.

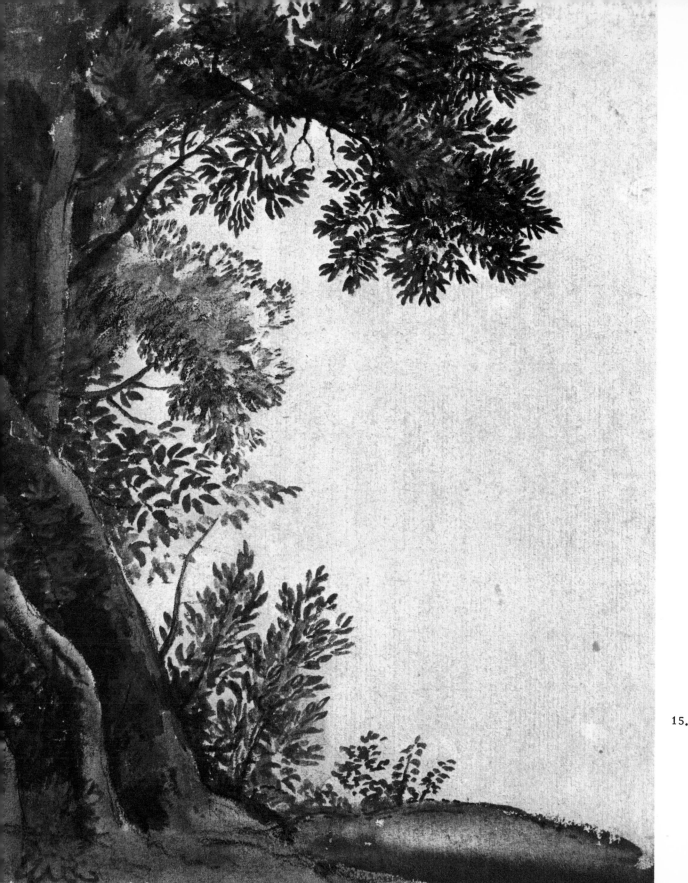

15. Trees (c. 1650)
    Paper tinted reddish,
    chalk, brown wash

    British Museum, London

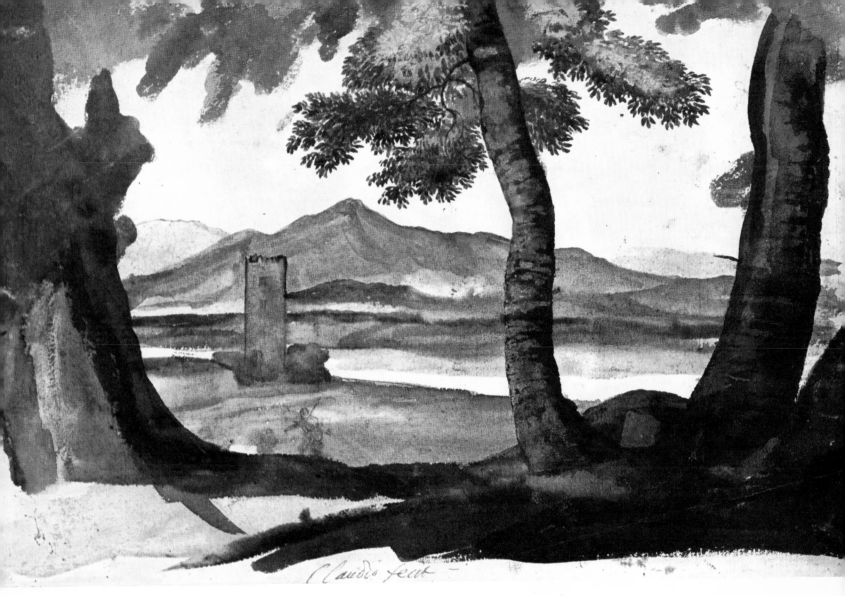

16. Landscape (1638–1640)
Chalk, brown and pinkish washes

British Museum, London

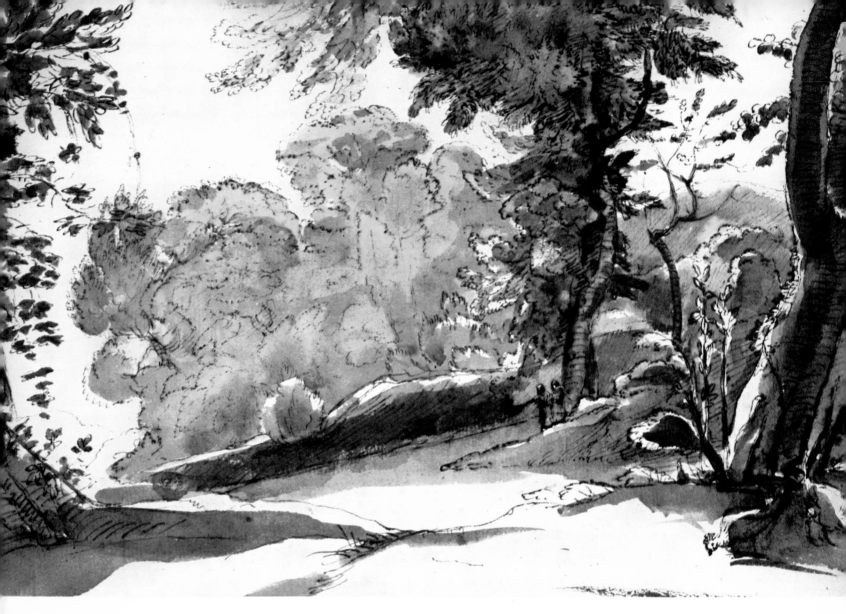

17. Wooded Scene (1640-1645)
Pen, brown wash

Teyler Museum, Haarlem

# Claude's Contemporary Reputation

What about fame? What did Claude Lorrain's contemporaries think of his work? How did they evaluate and rank it? Curiously enough he seems to have been prosperous rather than famous; his works seem to have been more sought after than praised. The only contemporary biographers who showed any direct interest in him were Sandrart, who was German, Baldinucci, an Italian. French taste, the grandiose taste which flourished under Louis XIV and the Academy, neither rejected nor glorified him. Landscape, to which he devoted himself, does not rank very high in the hierarchy of genres; attention tends to focus on the bigger themes.

And even in landscape painting Claude had a great rival, the universally admired Nicolas Poussin, who succeeded in combining heroic themes and landscape. Traditionally a parallel—and by no means an arbitrary one—has been drawn between these two French painters of the same generation, who lived next door to one another in Rome. As young men they set out on the same road to seek their fortunes. They made drawings together. But as grown men they seem to have had little contact, except for "the occasional pleasure of a glass of good wine" mentioned in a letter written by Abraham Brueghel in 1665. Poussin's copious correspondence contains no reference to Claude. Claude's studio boasted no work by Poussin. Yet they often shared the same patrons—among them the Barberini family—and sometimes the same clients: Maître des Comptes Passard, Brienne, and Baron von Mayer.

If we examine the list of Claude's clients more closely, we see that his buyers consisted chiefly of crowned heads and members of the high nobility. Poussin on the contrary was preeminently the painter of the intellectual bourgeoisie, the rising class, the century's intelligentsia. Among the bourgeoisie and lower nobility his success was assured by art lovers such as Fréart de Chantelou, who regarded the arts as one of the forms of intellectual culture. Poussin's painting lends itself to scholarly commentary, which the members of the Royal Academy of Painting directed by Le Brun readily provided. His work has furnished the starting point of an aesthetics, the basis of a doctrine. Nothing comparable is to be found in Claude. His art is too poetic, too spontaneous in its genius, ever to become the model for a school.

Hence Poussin's biographers—not to say hagiographers—make only passing reference to Claude. Félibien's *Entretiens sur la Vie des Plus Excellents Peintres* (1666-1688) devotes 135 pages to Poussin but only two lines to the man whose fame in Rome surpassed his. Roger de Piles, a detractor of Poussin, gives rather more space to Claude in his *Abrégé de la Vie des Peintres* (1699) but only in order to express some reservations about his talent: "Painting did not come easily to him, and when his work did not turn out the way he wanted it, he would sometimes spend a week doing the same thing over and over." De Piles says that Claude overcame his slowness by hard work, "which makes us realize how perseverance can offset sluggishness of mind," and that we cannot help admiring a providence which "lifted this painter out of his great obscurity to make him a man respected throughout Europe." It is almost with regret that he notes that Claude's landscapes "have earned him an immortal reputation all over the world." These judgments are somewhat startling since we know from Baldinucci that "cardinals and princes frequented his studio" and that when he died he left very few paintings, probably no more than ten, in his workshop. It seems that Poussin was awarded the moral standing and intellectual prestige, Claude the material success.

This success is confirmed by the number of forged Claudes in circulation even during his lifetime. Baldinucci tells us that while Claude was working for the King of Spain, "certain envious men, eager for dishonest gains, not only stole the compositions but even imitated the manner, and their copies were sold in Rome as originals from his brush." To outwit the forgers Claude acquired the habit of making a drawing of all his compositions in a big book which he called the *Liber Veritatis* and which enabled him to authenticate his own works. This book still survives; besides sketches of the paintings it contains names of purchasers and dates of execution, thus constituting a basic fund of material for all studies of Claude Lorrain's work.

18. Pastoral Landscape (c. 1645)
Paper tinted reddish, pen, brown wash

Louvre, Paris

Among Claude's forgers was a French painter named Sébastien Bourdon, who later became a member of the Royal Academy of Painting. Claude received him in his studio and unsuspectingly showed him the big landscape he was working on at the time. Guillet de Saint Georges reports in his biography of Bourdon that "M. Bourdon took a good look at it, went home, took a canvas of the same size, and a week later counterfeited the landscape so skillfully that when he exhibited it at a fête everyone declared that it was the best thing Seigneur Claude's hand had yet produced. This came as a surprise to Claude, and art lovers who came to see him told him that the work seemed to be absolutely identical with the one still on the easel. Seigneur Claude could not resist going to see it. He returned extremely angry and would have taken very violent measures if his imitator had not been careful to stay out of his way."

If Claude Lorrain's paintings were so widely forged even in the seventeenth century, it could only be because they were very rare and expensive. Have we any idea what they cost? Actually their prices varied throughout Claude's lifetime. Sandrart notes that a few years after arriving in Rome, Claude sold some landscapes very cheaply because they were not very well painted. As he became better known, his prices rose. His big pictures brought 200 to 250 scudi. (Claude paid a life-rent of 500 scudi for his house.) This was a considerable sum, but in some cases the price was even higher, depending on the rank of the buyer. In 1663 the Roman agent of Cardinal Leopold de Medici wrote to his master, who had commissioned him to buy some drawings by Claude: "He will have to be paid generously, because he fixes a price only for people of mediocre position." We do not know whether this system applied to the paintings too, but Baldinucci relates that when Pope Clement IX wished to buy one he "offered him as many doubloons as were necessary to cover it completely, but it was never possible to get it out of his hands, because he said, as indeed was true, that he used it every day to see the variety of trees and foliage."

This aspect of Claude offers an insight into his personality: prosperous but not interested in money; rich but not ostentatious. He attached more importance to his craft than to money; his artistic integrity was beyond reproach. Claude may have been a poet, but he was also inventive—that is to say, a good workman, a good artisan of painting. This held true throughout his life, despite success and the temptations of facility. We must now try to define the craftsmanship and the art of Claude Lorrain.

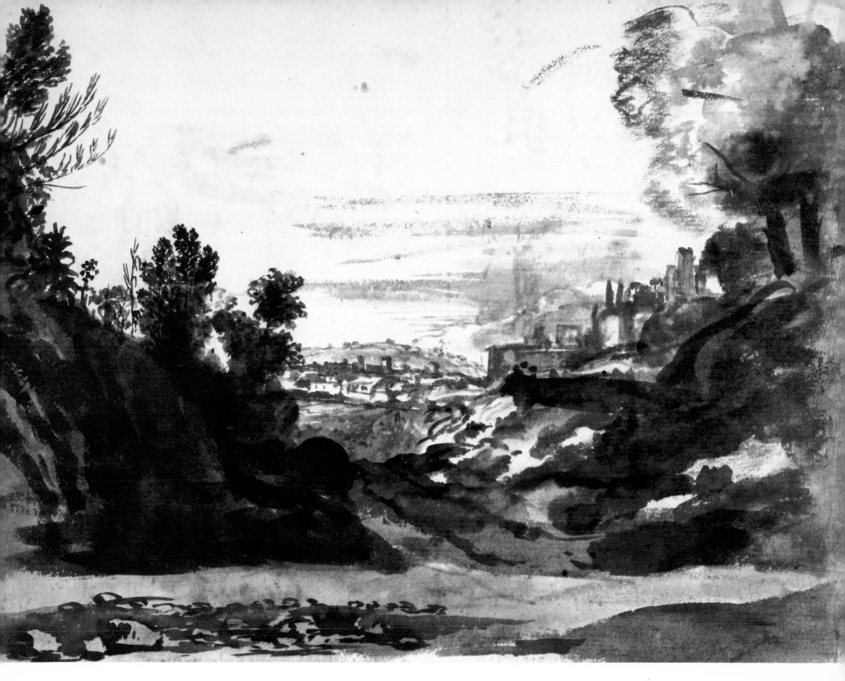

19. Landscape (c. 1635)
Brown wash

British Museum, London

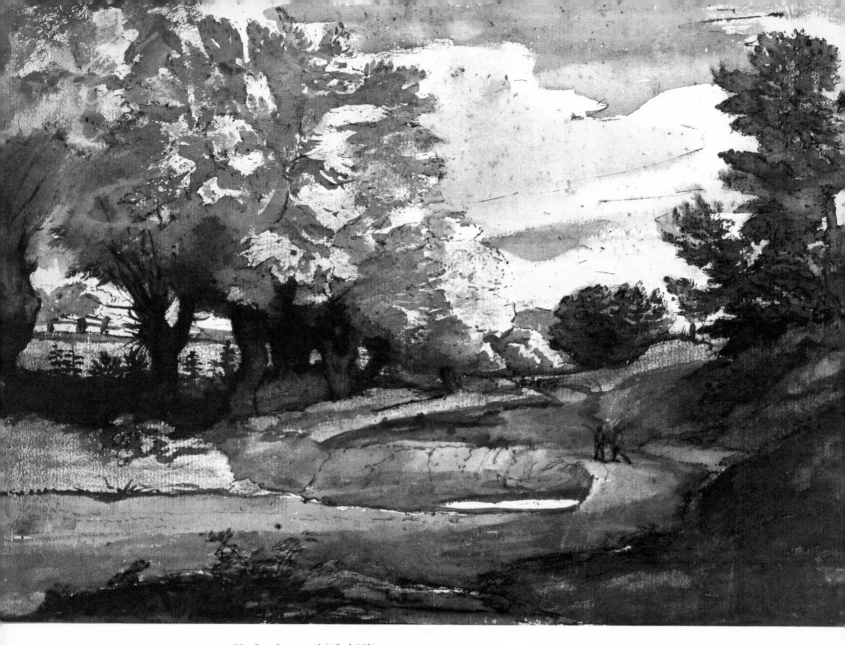

20. Landscape (1640-1641)
    Pen, brown and red washes

    British Museum, London

# II

# The Art of Claude Lorrain

The tradition to which Claude Lorrain's art belongs is landscape painting. He never attempted any other theme, never went beyond the strict limits of this genre, which, important as it was, was not nearly so highly esteemed in his time as historical subjects. This specialization, which put painting almost in the category of a craft, was very indicative of the artist's situation in the seventeenth century. Apart from rare exceptions, he was no longer a genius expected to combine versatile skills with the qualities of a courtier, like Leonardo or Raphael in the age just past. Instead of being dependent upon an individual prince or patron, he was self-supporting. He produced works which were bought to become part of collections representing all types of painting: historical, portrait, genre, still life, and landscape. Landscape painting was very popular in the seventeenth century; it was in great demand throughout Europe and had already established its own traditions and local characteristics. One reason for its success was the important part it played in interior decoration. The custom of adorning state apartments, especially galleries, with scenes of courtly life and views of cities dates back to the sixteenth century, but it reached its peak in Paris in the early seventeenth. The Flemish landscapist Jacques Fouquier (or Fouquières), one of the celebrities of the day, had settled there. Another landscapist, Philippe de Champaigne, decorated Richelieu's Palais-Royal. The same thing happened in Rome, where a whole colony of northern artists painted landscapes to embellish palaces.

This love of landscape, both in nature and for interior decoration, is reflected in the literature of the time, especially its novels. (Honoré d'Urfé's *L'Astrée* is a good example.) It is one of the basic characteristics of seventeenth-century man, who, visually oriented, derived his knowledge of the world from direct confrontation with nature. In science the notion of experiment was just emerging. Perception was no longer expected merely to furnish abstract knowledge for edifying purposes, as had been the case in the Middle Ages and even in the sixteenth century, but was itself becoming a subject of study and delight. Previously, paintings had been "read"; now they began to be "seen." Discoveries in the field of optics came thick and fast (Galileo, Descartes, Leeuwenhoeck); so did treatises on perspective.

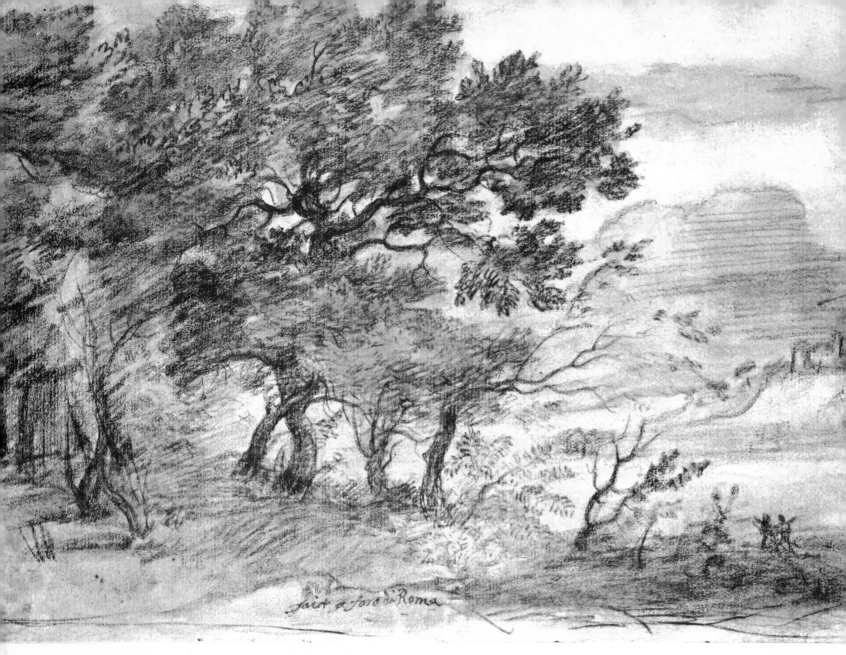

21. Trees (1640-1645)    Cream paper, chalk, light brown wash          British Museum, London

In 1648 the study of perspective was introduced at the Paris Academy. Significantly, it was not only linear perspective that excited people (that is, the study of the relative size and shape of objects in a given space) but also aerial perspective, defined by Abraham Bosse as "the blending or merging of the air with the other colors to suggest the depth of objects according to their angles and their position along the lines of perspective."

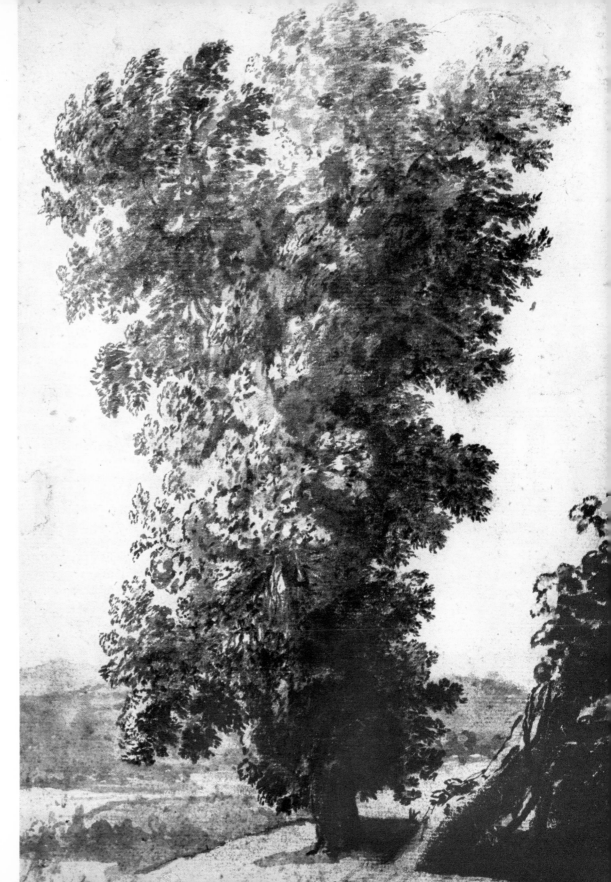

22. View with Trees (1635-1638)
   Chalk, brown wash

   Uffizi, Florence

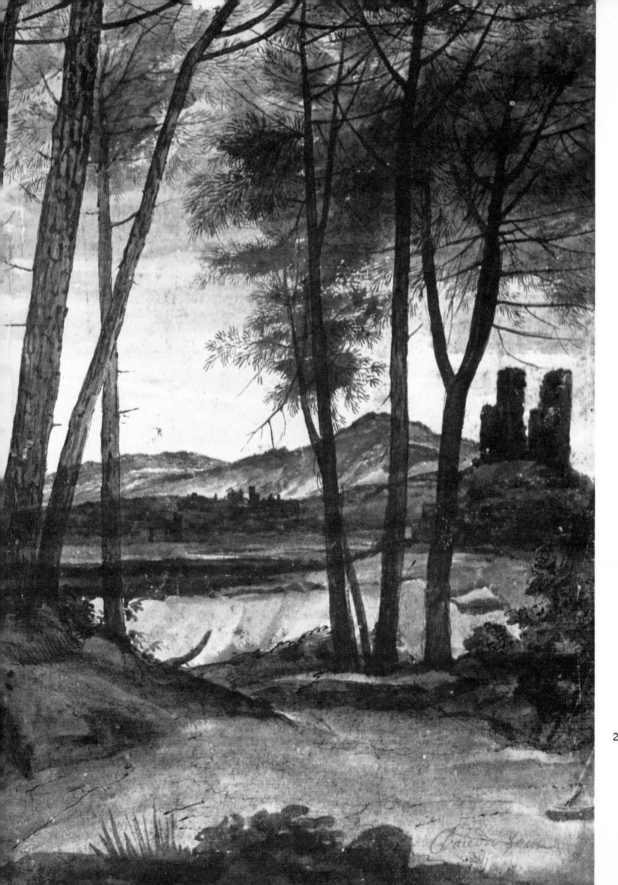

23. Landscape (1638-1639)
   Pen, brown, gray and pink washes

   British Museum, London

It may be objected that landscape had begun to emerge as an independent genre much earlier. Certainly no one can deny the importance or beauty of sixteenth-century panoramic landscapes like those of Patinir or Altdorfer, not to mention the backgrounds in Leonardo da Vinci's works. The seventeeth century inherited this cosmic conception of landscape, but it was not long before variations began to appear. In the North, especially in Holland, a realistic trend treated landscape almost like portrait painting. A study of a town or of a rural or water scene sought to present an attractive impression of a particular region and way of life: that of a small independent country, active and prosperous. In Italy two separate conceptions developed. So-called heroic landscape served as background for scenes from mythology or legend; an idealized nature provided a sublime, timeless setting for the subject. In pastoral landscape, on the other hand, the picturesque element was more important than the idea. The Bolognese painters of the late sixteenth century exemplify both these types. The Flemish treatment of landscape is less theoretical, less codified, especially that of Paul Bril, who was very influential. The tranquility of his compositions, his striving for depth, and the luminosity of his harbors and ships seen against the light deserve particular attention in the present context.

Where does Claude Lorrain stand in relation to these trends? First of all, we must remember that he lacked the clear overall view of the problems confronting him that we have gained from modern research and abundant documentation. Neither his choice of an original style nor the development of his personality followed distinct, preestablished lines. His style crystallized gradually out of a vast European trend, precipitated by the atmosphere of Rome in the 1630's, that melting pot of diverse tendencies. He acquired his experience firsthand, through the paintings of the landscapists working in Rome in the early seventeenth century such as Bril, Elsheimer, and the Bolognese painters, and through engravings, the principle vehicle in the dissemination of art in those days.

To define the artistic climate of Claude's early years we must therefore go back to his biography. His experience with the landscapist Agostino Tassi unquestionably left its mark, as can be seen from the early frescoes, such as those he painted for the Crescenzi palace in Rome in 1630. Moreover, his original biographers speak of him as a pupil of Tassi. This painter, who lived from 1581 to 1644 and was trained by the Flemish master Bril, painted decorative frescoes depicting landscapes enlivened with all kinds of picturesque elements: craggy rocks, silhouetted trees, views of rocky shores, groups of rustic or mythological characters. Sandrart writes that he made many paintings of "architecture, friezes, and other work in the chambers of the cardinals as decorations above the tapestries; also perspectives and other work."

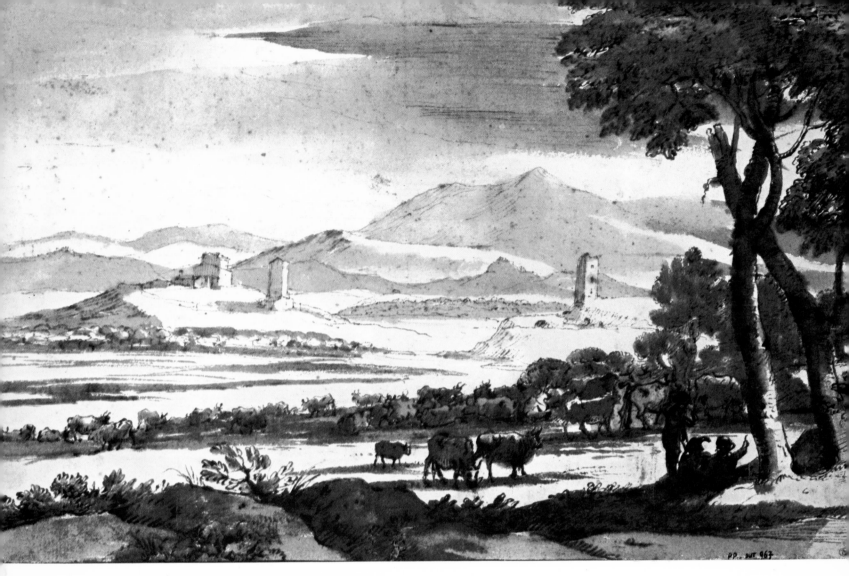

24. Tiber Valley (dated 1643)
Pen, brown wash

Petit Palais, Paris

# The Artistic Vocabulary

The whole of Claude Lorrain's artistic vocabulary, what we might call the raw material from which he was to fashion his personal vision of the universe, is to be found in the paintings of Tassi and Bril. The work of these artists also illustrates the interest in trick perspective characteristic of the age. *Trompe l'œil* was used to break holes through walls, to startle or amuse the viewer, to expand space, or to add the finishing touch to a decoration. This accounts for the popularity of the *veduta* in the early seventeenth century. The *veduta*, a view of real or imaginary monuments seen in striking perspective, was a favorite device of several northern artists (notably Herman van Swanevelt) who were working in Rome when Claude began to paint. Sandrart speaks of Claude's learning this technique: "He applied himself to perspective; having soon grasped its fundamental rules, he turned to drawing, which however did not suit him at all, since he could develop neither an individual manner nor delicacy; so that he kept to the former and in a few years learned so much that he established himself on his own and painted landscapes with buildings."

Perspective and buildings—these are the two key words for Claude's early experience. From 1636 on, his work consists essentially of *vedute* such as the *Campo Vaccino* (c. 1636) in the Louvre. He also painted landscapes with buildings, that is, landscapes decorated with imaginary monuments, sometimes in ruins, which are often referred to as "caprices" because of their light mood (the *Harbor Scenes* in the Louvre, for example).

But while Claude may have derived the basic elements of his style from his age and his contemporaries, we should not assume that his genius consisted merely in utilizing all of these diverse elements or in utilizing them more effectively. In fact—and this is the crux of the problem of artistic creation—Claude's landscapes never suggest juxtaposition. There is nothing eclectic about them. Their impact stems from a total, integral perception, a fresh vision of the universe. Claude succeeded in fusing form and substance, linking foreground and background so powerfully that his mature works evoke an unprecedented feeling of intangible space. The segment of reality enclosed by the canvas becomes unique, its various components dissolved by the alchemy of light.

What kind of plan determines the organization of these components? Certain types of composition recur throughout Claude's work: a view of a distant plain framed by the dark masses in the foreground; a clump of trees filling two-thirds of the paper; an oblique view with a grove of trees in the middle distance. The type of composition also varies with the subject. In his seaport paintings the solid verticals of palaces are echoed in the ships' masts—a closed composition in which the only opening is the sea. Dancing shepherds weave their patterns in open spaces ornamented with the sinuous rhythms of intertwining tree trunks.

The first impression that Claude's work evokes is unity within variety. His compositions present melodic sequences of forms. The eye travels from the rounded mass of foliage to the sharp silhouette of the column, then follows the twists and turns of the stream, punctuated here and there by a humpbacked bridge. By imperceptible modulations it is guided toward its journey's end: the horizon, the threshold of the sky, and the source of light.

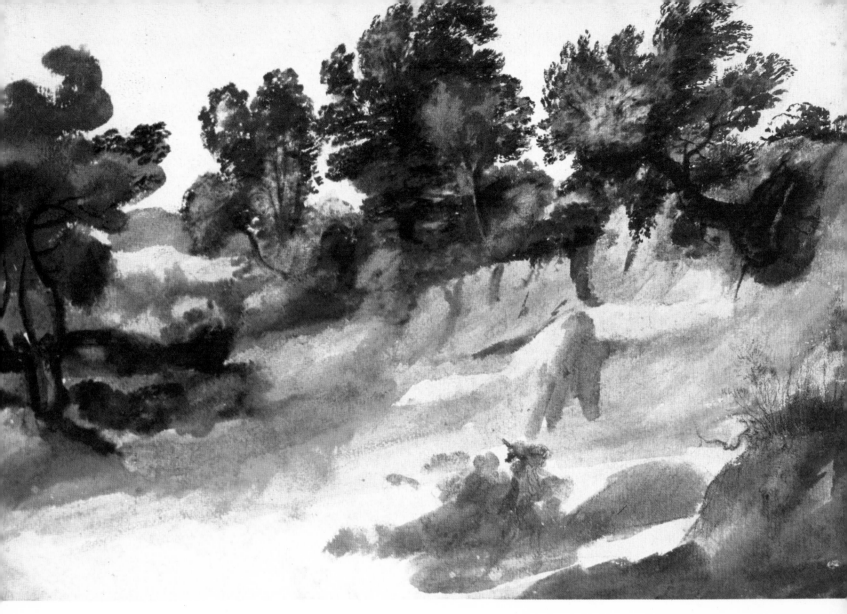

25. View with Trees
    Chalk, brown and pink washes

British Museum, London

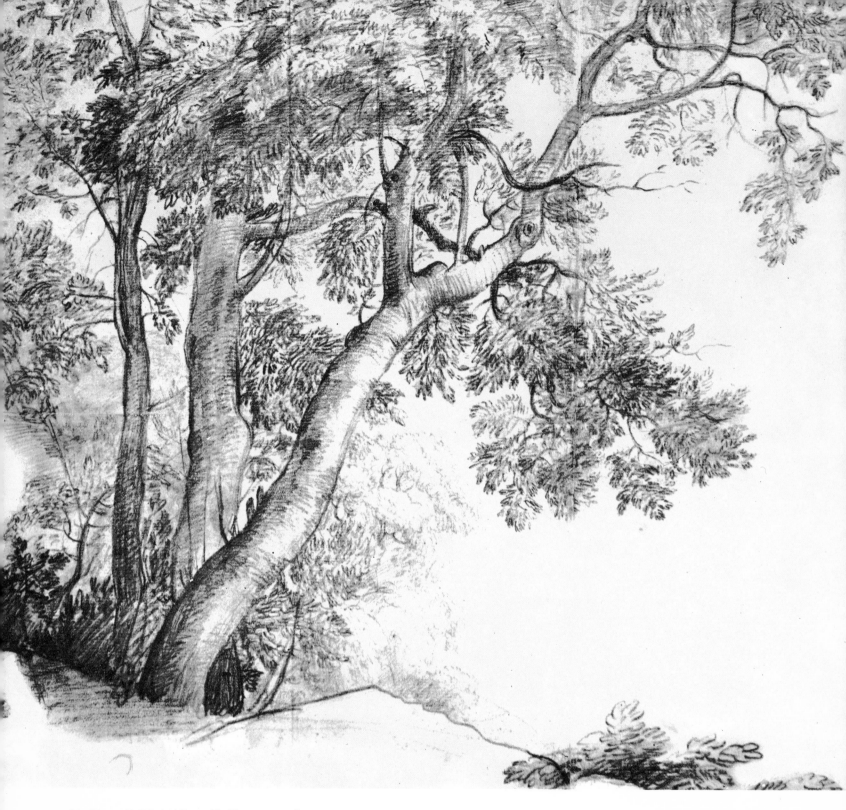

26. Trees (1655-1660)    Chalk, gray wash

# The Radiant Void

Indeed, everything in Claude's compositions is oriented to the radiant void of the sky, the light emanating from it, the heavenly bodies, the sun or moon, inhabiting it. Its power of attraction is so strong that all anecdotal elements disappear, giving way to a vast resplendence. The horizon, constantly receding even beyond the limits of the canvas, beyond reality, beyond legend, seems to beckon toward the infinite. It is both presence and absence, primary justification and final apotheosis. In pursuit of the sun, Claude leads us to the borderland of dream and reality. His world lies at the far edge of the tangible and the imaginary; precise enough to be believable, it opens on unexplored realms, inviting us to break away, leading us to pure contemplation. Claude, the painter of light, and through light of the immaterial—that is to say, of space—makes us aware ofwhat Abraham Bosse called "that unifying element of air, which surrounds objects just as the element of water surrounds the fish."

Yet when the historian begins to analyze Claude's paintings, what a strong narrative element he finds! The temples, ruins, buildings, trees, and even the light should not lead us to overlook the human figures. They exist. They even made Claude the great historical landscape painter of his day, the painter of landscape within which man becomes legend, and nature his counterpoint in a privileged symbol of Creation as a whole. Hence the importance of the human figures in his work.

Most modern criticism has dismissed this as Claude's need to accommodate himself to the fashion and conventions of his time. Yet, in fact, there are plenty of seventeenth-century landscapes with no mythological or heroic content at all. Holland legitimized this type of pure landscape as a genre. The seventeenth-century art lover gave it a favored place in his collection. Thus, if Claude opted for historical landscape, it was not because no other choice was open to him but because it provided the scope he wanted.

His choice was progressive. As Marcel Röthlisberger showed so conclusively in his article on the themes of Claude Lorrain's paintings in the *Gazette des Beaux-Arts* (April, 1960), literary and mythological subjects are rare in the early works. The brigands, huntsmen, and dancing peasants in the foreground have no particular relevance to the background landscape. In the mature works, however, the relationship becomes increasingly close. We even have reliable evidence that this was Claude's main concern. At first, like most artists of his time, he worked only on commission, and these commissions always included two precise stipulations: the dimensions of the painting and its subject. Moreover, he used to record minute notes of the subjects in his *Liber Veritatis* or sometimes on the canvas itself, occasionally even citing the chapter of the *Aeneid* or the *Metamorphoses* it illustrated. This is further proof—if there is need of any—that he was far from being the illiterate peasant he has been made out to be. Only after his death were his most famous works given new, vague, romantic titles like *Evening* or *Morning*—an indication of the oblivion into which his themes had fallen.

This disparagement of Claude Lorrain's human figures has been reinforced by another legend: that he relied on other artists to help him to paint them. It seems that such collaboration, if it ever occurred at all, was limited to a few early works in which the subject was in any case of little importance. A Dutch painter, Pieter van Laer, leader of the Bambocciati, is said to have been the collaborator. This practice was, of course, common in the seventeenth century, and Claude very likely followed it. Indeed, all his contemporaries comment on his lack of talent for the human figure. To quote Sandrart: "However happy this beautiful spirit is in representing well the naturalness of landscapes, so unhappy is he in figures and animals, be they only half a finger long." This "weakness" is not apparent to the museum visitor of today. Even if Claude's human figures are not always perfectly drawn by academic standards, they are well integrated into the landscape. Their bright accents heighten the brilliance of the picture, add to its movement and general light, and contribute significantly to its poetic force. This is borne out by his own development.

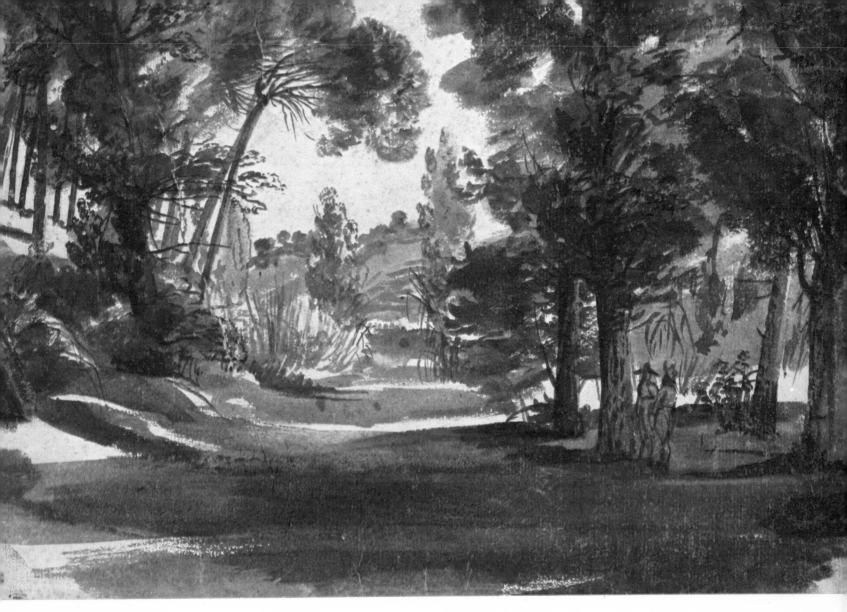

27. Wooded View (1635-1640)
Chalk, brown wash

British Museum, London

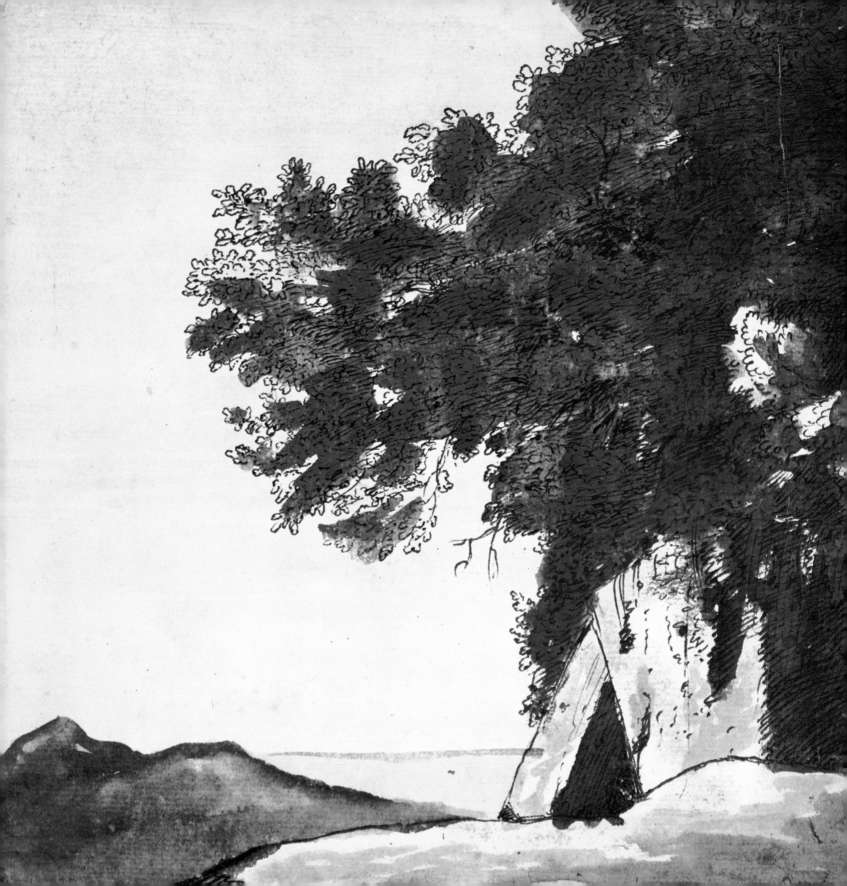

# Subject and Setting

At the age of forty Claude began a determined effort to achieve an emotional correspondence between subject and setting in his paintings. The *Landscape with Rural Dance* (1639, Louvre) is set at the edge of a wood in open, serene country. The *Flight into Egypt* (c. 1639, Doria Gallery, Rome), on the other hand, is sombre in tone. The landscape is dense and thickly wooded, with palm trees to symbolize the Orient. After 1650 the subject matter of the paintings became more important. Claude sought themes suitable for dual development which he could treat in pairs: two matching pictures of identical dimensions, having the horizon at the same height. These paired paintings are to be read from left to right and are complementary in both edifying content and emotional atmosphere.

The Expulsion of Hagar and *Hagar and the Angel* (1668, Alte Pinakothek, Munich) are good examples of such a pair. In the *Expulsion*, the composition is closed on the left by the mass of the palace. Hagar faces right, toward the immense plain illuminated by the morning light and the distant mountain at the extreme right. This mountain is repeated in the second painting, this time at the extreme left. Time has passed. Evening has fallen, and the space is closed on the right by interlaced trees forming a dark mass which corresponds to the palace in the first picture. The two works balance each other in a dual way. They are individually balanced in that in one picture the palace has its counterpart in the mountain, and in the other the mountain has its counterpart in the trees. They are also balanced as a pair in that the two mountains are sisters, and the mass of the palace in the one corresponds to the mass of the trees in the other.

28. View with Rocks and Trees (1630-1635)
    Pen, brown wash

Albertina, Vienna

The study of these matching pairs is essential for an understanding of Claude's work.  Nearly all his pictures were painted in pairs, certainly all those of his maturity and old age.

Why did he do this? The buyer or the painter himself would suggest either two episodes from a single theme (the expulsion of Hagar followed by her encounter with the angel) or two different subjects pertaining to the same theme, such as the two avatars of royalty in the Louvre's *Landing of Cleopatra in Tarsus* (1642) and *Samuel Anointing David* (1643).  This practice reveals some principles governing the hanging of paintings that we cannot understand today without studying the architectural setting they were intended for.  These principles of display were in fact the exact opposite of current museum practice.  Paintings were not separated by blank spaces where the eye could rest, but surrounded by gilding, stuccowork, and statues.  Strict rules determined the position of every picture.  J. F. Blondel, an early-eighteenth-century theoretician, was echoing these rules when he recommended never hanging a landscape over a door or window, because one empty space should never be placed above another.  There were equally rigorous rules for the division of wainscoting into panels and galleries into bays.  It was in state rooms like these that collections were usually displayed.  All these rules of balance and symmetry, now long forgotten, show the usefulness, not to say necessity, of matching paintings in pairs.

Most of Claude's pairs became separated over the years, but thanks to the scholarly research of Röthlisberger many couples put asunder by history have now been reunited.  Their themes are generally taken from the Old and New Testaments, the lives of the saints, and Ovid's *Metamorphoses*. One of Claude's favorite sources in his old age was the *Aeneid*, which offered scope for scenes involving plenty of characters, such as the *Coast of Libya with Aeneas Hunting* (1672, Musée des Beaux-Arts, Brussels) or the several versions of the *Landing of Aeneas on the Tiber* in English private collections.

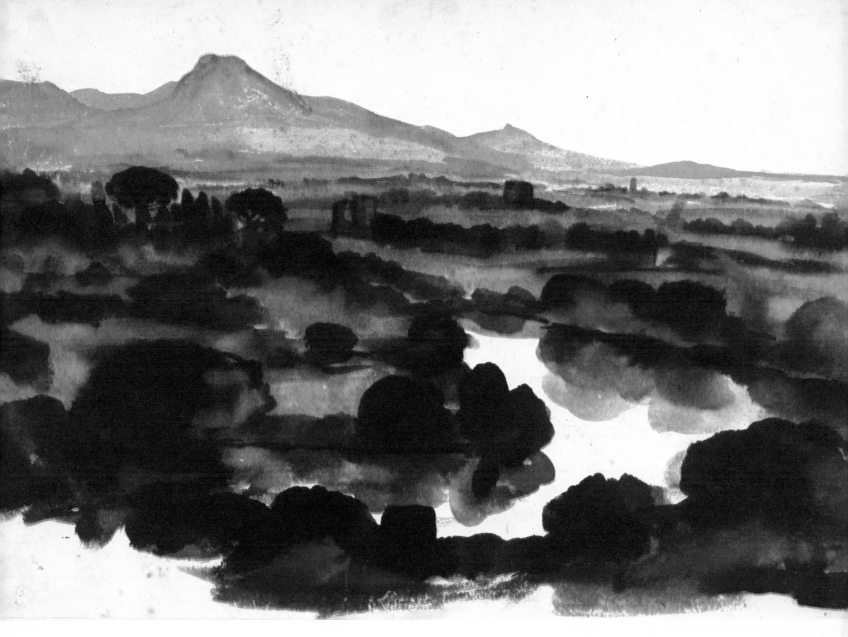

29. View from Monte Mario (c. 1640)
Brown wash

British Museum, London

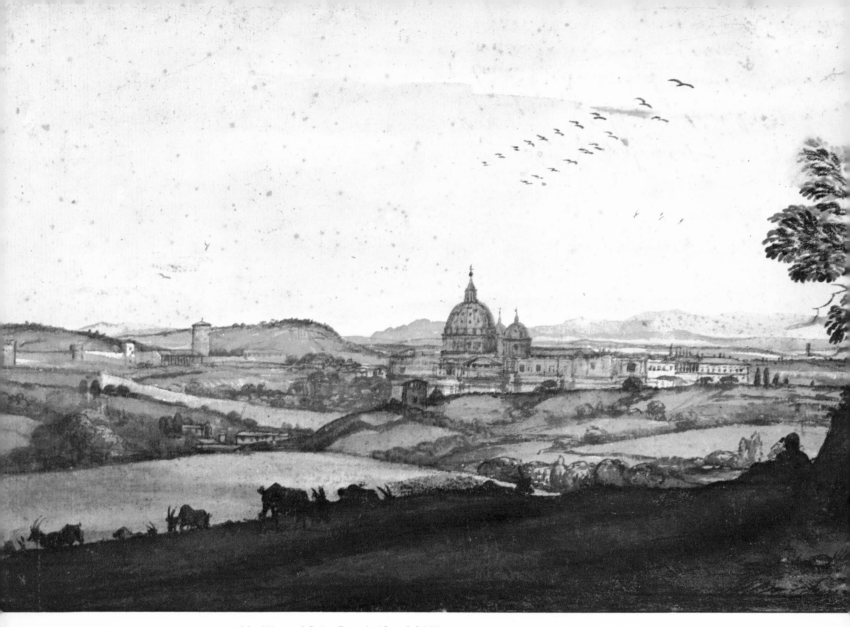

30. View of Saint Peter's (dated 1646)
Brown and gray washes, some pen

British Museum, London

# Toward Perfect Harmony

C laude Lorrain's style reached its peak in these last works. His landscapes are sublime. Every element is perfectly balanced. The momentary light becomes eternity in a marvelous fusion of color and substance. His handling of space is masterly. There is no conflict between form and background, theme and setting. Everything becomes *vision* in the strongest sense.

Thus every picture presents a theme, a setting, and a moment in time, brought together in a unique, precise relationship. The aim of Claude's late works was to tighten this relationship to the point of utmost harmony. The content of these paintings was never a matter of chance; the harmony was never accidental. Through an extraordinary capacity for orchestration he raised anecdote to the level of myth, landscape to the level of dream, transformed light into dazzling luminosity. His work is far from being a series of lucky successes followed by setbacks; it demonstrates extraordinary tenacity, a determination to discover the secret link or affinity between knowledge and feeling. His style does not derive from any rigid formula but from a striving for modes, for "scales" in which the individual elements of light, color, subject matter, and composition come together, so to speak, in chords to create variations on what we might call the heroic, the tragic, the sublime, or the serene mode.

Like many of his contemporaries, Claude tried to correlate colors and modes. He rendered light through color rather than by contrasting light and dark in values tending toward white and black, as all other seventeenth-century painters did. He used color itself to create a dominant tonality: blue-green for morning landscapes, pinkish orange for evening ones. To every tonality corresponded a symbolic abstract idea. (Here Claude was simply applying contemporary theories.) Divinity and serenity were denoted by blue, the power of love by red, splendor by yellow, hope by green. The relationships between form, theme, light, and color thus became extremely complex and permitted infinite variations. They produced an art of generalization which is in no sense cold, formalized academicism, but achieves that perfect balance of feeling and thought that was the highest goal of seventeeth-century man.

How much of what Claude was seeking can we still appreciate today? Many of his concerns are foreign to us now. The cultural references in his landscapes are for the most part obscure; their literal meaning is dead. But miraculously all this now-meaningless background springs to life again in a new way, never failing to move us afresh. This is a privileged language. The words are lost, but the tone remains. It moves us by its inflections, its inward melody. Its universe remains intact. This universe, stripped down to its bare essentials, existed within Claude himself. We shall find it in his drawings.

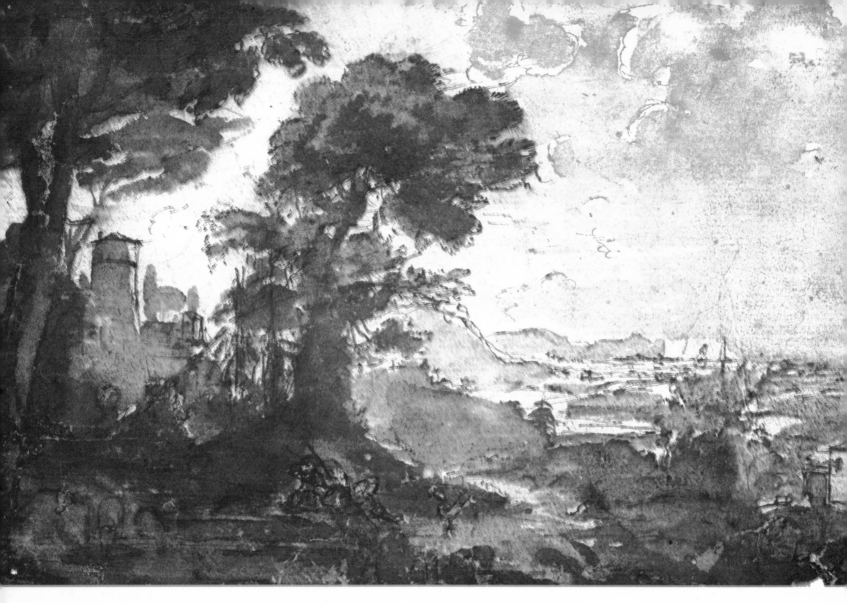

31. Landscape with Narcissus and Echo (c. 1644)
Pen, brown wash

British Museum, London

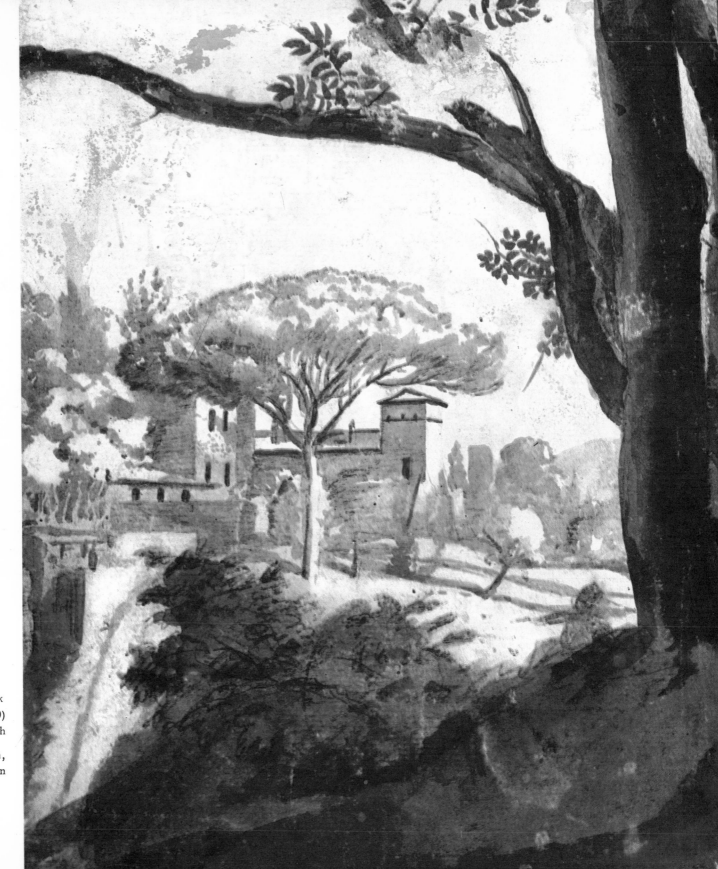

32. View in a Park
(C. 1650)
Chalk, brown wash

British Museum,
London

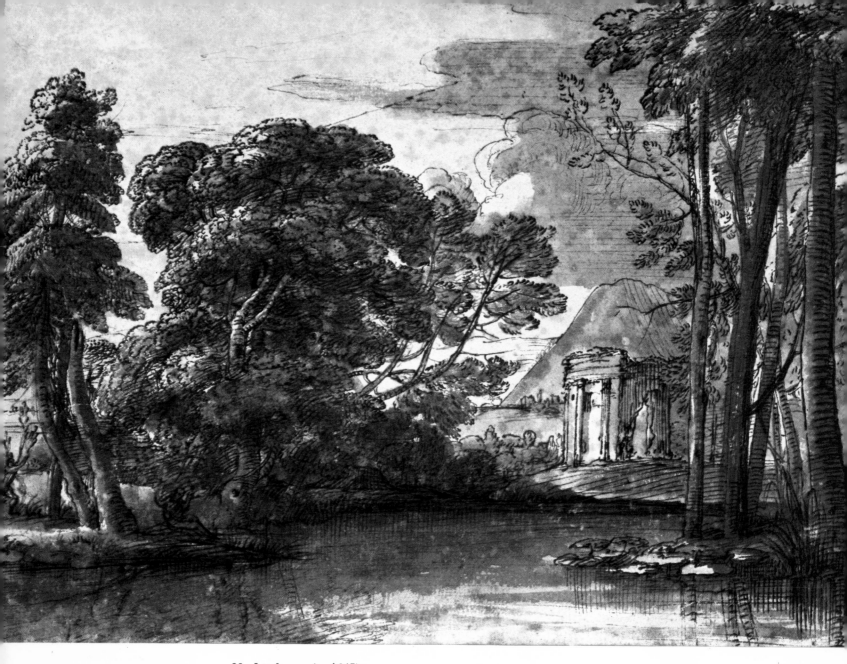

33. Landscape (c. 1645)
    Pen, brown wash

    Musée Condé, Chantilly

# III

# Drawing:
# The Sentence and the Word

Claude's drawings are a vast domain. Almost a thousand drawings hidden away in portfolios have retained their full freshness and luminosity. Here they reveal their beauty, bridging a gap of centuries during which they were known only to a few art-lovers.

Why and for whom did Claude Lorrain draw? The wide dispersion of his drawings today, their complicated, often obscure history, and their journey from studio to private collections and thence to museums show that they have always been highly valued. Even in Claude's lifetime they were rare and sought after, since the painter wanted to keep them for himself. A contemporary wrote in 1622: "M. Claude has some old drawings, but very few, and he does not want to part with them, saying that he uses them." This is borne out by the fact that during his lifetime some of his drawings were numbered and bound in sketchbooks so that he could more easily refer to them or in order to create a sort of anthology of his graphic work. Thus Claude's drawings constitute a record of his lifework; he used them as a means of study, and they constantly nourished his pictorial creations.

Are we justified in discussing them independently of the work or works to which they refer? Our scrutiny must take into consideration the intimate, private world they introduce us to. Here we are dealing not with the creator of sublime, grandiose visions, the father of legendary heroes, but with Claude the man, stripped of his worldly trappings and intimately confronting nature and art. We are asking him to tell us something of his personal approach.

He tells us two things about it. First, we see evidence of his direct contact with the external world—primarily a visual contact, the instantaneous movement of his hand which captures and reevokes the impression. Secondly, we see the slow, careful process of correlating all the diverse elements and integrating them into the final composition. The first involves the study of Claude's vocabulary, the second of his syntax. Two different types of drawing correspond to these two basic functions. If we look closely, we can distinguish both of them in the great body of material at our disposal.

Claude Lorrain drew his vocabulary from nature. It strikes us at once as original. When he looked at his subject—a tree, say—he immediately conceived it as an indivisible entity, an unsplitable atom. He did not share the Renaissance curiosity which led Dürer or Leonardo to botanical or scholarly research designed to penetrate the anatomical mysteries of an object and lay bare the constitutional principles it shares with all other members of its kind, thus contributing to the knowledge of nature. What Claude was after was the essential individuality of the object before him. He made no attempt to relate it to a common genus but rather insisted on its specific differences, immediately bringing out its individuality. Far from pursuing his examination down to the smallest detail, far from seeking to explain the forest *(Fig. 13)* by the tree, the tree by its branches, the branches by their leaves, he conceived the forest as a whole, having its own life, its individual rhythm, its irreducible character and personality.

In this vocabulary every word is the product of a synthesis brought about by an eye which unified, related, and saw as a whole. This synthesizing process to which Claude subjected even the most modest objects like rocks or tree trunks is essentially no different from the process that determined the organization of his most complex compositions. He confronted a blade of grass and a full-scale orchestration of myth and legend in exactly the same way. His big paintings are no different in kind from the most spontaneous of his drawings; the difference is merely one of degree. The same synthesizing process is at work in both. The preliminary sketches for paintings may contain a greater variety of elements: trees, plains, towers, ruined monuments, animals, and people, but Claude linked them exactly as he linked the leaves on one branch or the branches on one tree. One concern was always uppermost: to capture the individuality of the scene, to personalize it by organizing details into masses, masses into forms that would balance one another, and to unify the whole by suffusing it with a dominant tonality of light and emotion.

In the drawings from nature his eye spontaneously achieved this synthesis. In the big compositions more thought was involved, but it proceeded in the same direction and merely reinforced the synthetic process. Thus Claude's syntax helps us to understand the elaboration of his vocabulary. The inflections of the sentence reveal the meaning of the words. In the preliminary sketches for the large compositions, certain distinctive traits reveal how reflection reinforced his eye—the treatment was less improvised; the pen or brush delineated the contours more serenely; the flatness of the wash distributed the light in precise rhythms.

34. Landscape Studies (1630-1635)
Pen

British Museum, London

# The Liber Veritatis

Claude Lorrain's graphic *œuvre* is enriched by a third type of drawing, unique of its kind: what might be termed the *a posteriori* sketches. These were drawings made expressly to serve as a record of his paintings, showing not only their general layout but also the most minute details of subject and composition. As we have already noted, Claude collected these drawings in his now famous *Liber Veritatis*. In 1636 he began to make them in a bound sketchbook with sheets in alternating groups of four white and four blue. Later he carefully recorded every painting that left his studio and must even have added some older ones, since the earliest dates from 1634. The *Liber Veritatis* constitutes a catalogue of 195 drawings through which we can trace the painter's development. His major compositions are all represented. The ones he omitted are for the most part replicas or the second of a pair. The *Liber Veritatis* is a precious tool for the historian, enabling him to follow Claude's progress through a long lifetime of work. The painter himself attached the greatest importance to this book. It enabled him to authenticate his own works and expose forgeries, and he also used it as a handy catalogue of finished compositions from which his clients could make selections. This explains why Claude produced so many variants and replicas of his own work.

What does the *Liber Veritatis* offer on the artistic level? Proof of the draughtsman's tremendous skill, of his capacity to transpose into graphic terms and reduce dformat compositions, which were often vast in scale and full of human figures. Here Claude's draughtsmanship is remarkably well adapted to its function. The hand is steady; the fine, even line permits the utmost precision in even the most minute notations. Moreover, the *Liber Veritatis* clearly proves that Claude Lorrain was primarily a painter, that all his efforts were directed toward his painting and that for him drawing was no more than a way of making notes of the world around him, planning compositions, or recording a finished painting.

Dézallier d'Argenville, an eighteenth-century French connoisseur who had personally handled the *Liber Veritatis*, wrote in his *Abrégé de la Vie des Plus Fameux Peintres*, published in 1745 : "In his pen drawings Claude always broke off the stroke abruptly: he often depicted foliage by means of rather irregular dots. For shadows he used bister or India ink. To avoid applying white with a brush he would sometimes leave the paper blank—an unusual habit in a painter."

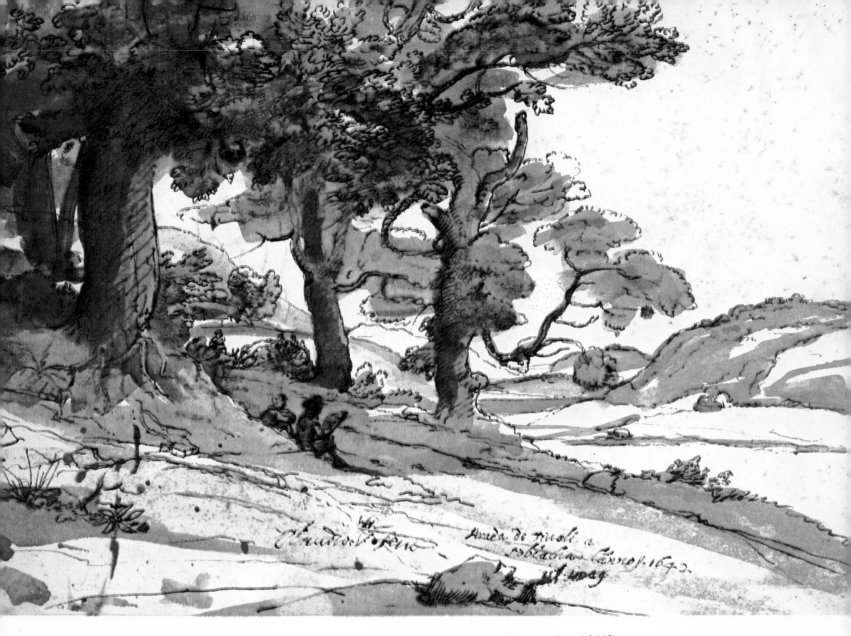

**35.** View Between Tivoli and Subiaco (dated 1642)
Pen, brown wash

British Museum, London

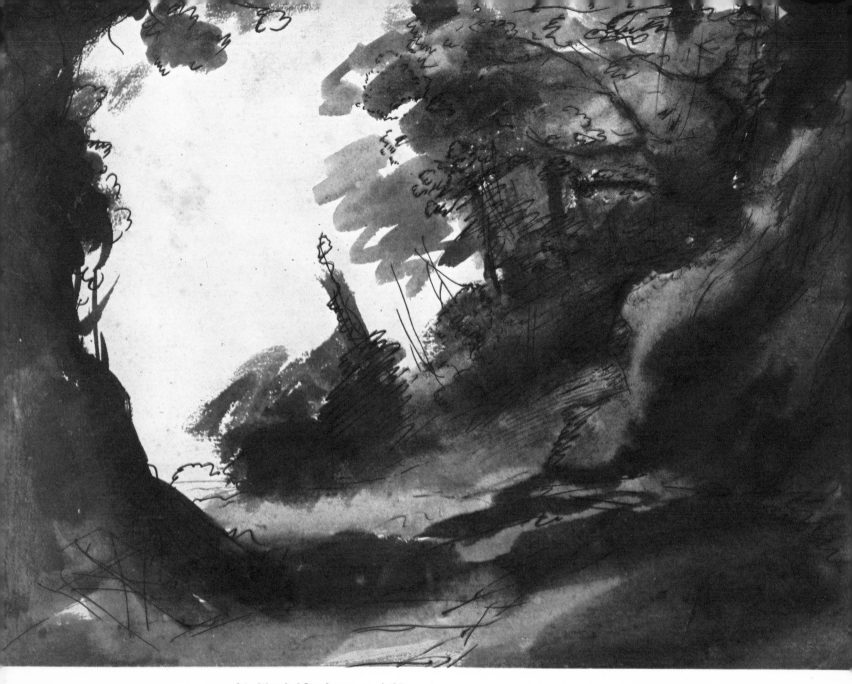

36. Wooded Landscape (c. 1635)
Pen, brown wash

British Museum, London

# Technique and Vision

This brief description covers all the technical devices Claude used in his graphic work; they are simple and few in number. He never worked in watercolor or pastel, or in charcoal combined with red and white chalk; in short, he never used color in a pure, intense state in his graphic work. He preferred the more subtle effects and more restrained technique of wash drawing in which diluted brown bister ink or black India ink is applied with a brush. With this means he could obtain variations of shade ranging from light beige to dark brown and from gray to black. The effect of the wash may be heightened with accents in pen and ink, or, if a very fine brush was used, the wash itself served as the graphic medium. Sometimes certain parts of the sketch were filled out with lines or stumping in pencil or black-lead. Sometimes, although more rarely, the drawing was executed entirely in pen and ink or pencil.

The simplicity of technique is astounding, far from being monotonous or perfunctory, the results are infinitely varied. This indicates the extent of Claude's talent. He was capable of writing for a full orchestra—of exploiting all the resources of his palette. Yet within the more intimate limits of the string quartet—to which drawing may be compared—he achieved an equal richness and range of emotion.

Claude Lorrain's different kinds of drawings arouse emotions of varying nature and intensity. The most spontaneous and direct drawings are those from nature; here he came closest to the sensibility of the present day. Yet it would be quite wrong to regard his nature drawings as simple statements of what he saw, as faithful, realistic renderings of the world as it appeared to him. The least stroke implies a process of transposition and selection which makes the work unique and irreducible in character. The simplest sketch is a vision, never a literal image. This is borne out by the lack of identifying features in his sketches of the Roman Campagna, where he learned to draw. The site is rarely particularized. What he was after was the general atmosphere. As we leaf through these pages, we find no mere topographical views or drawings of pure virtuosity dictated by manual dexterity; instead we find out how Claude saw things.

His vision changed in the course of his long career. In his early years it showed more movement and contrast, acquiring balance and clarity as he grew older. The *Pastoral Landscape* of 1635 (*Fig. 11*) reflects the impetuosity of youth. The blacks and whites are in violent contrast; the strokes are vibrant, jerky, and evocative, the general atmosphere disquieting. *Trees* (*Fig. 26*), on the other hand, suggests lightness and serenity. In this study from nature the distribution of masses, the general layout, and the calligraphy of the foliage stem from a calm, confident interrogation of reality rather than a momentary impulse.

Although Claude drew constantly, the amount of time he gave to it varied. Few of his drawings date before 1630. His most intense period of graphic activity occurred between 1635 and 1650, when he was exploring the Roman Campagna with Sandrart. During this time he developed the basic vocabulary which he was constantly to use. But even during these years compositional sketches began to appear, becoming steadily more numerous as he got more and more commissions for large oil paintings requiring preliminary sketches. On the other hand, as he grew older he made fewer drawings from nature, either because he thought he had acquired enough visual mementos or because he lacked the time for country expeditions or possibly on account of his health, for he suffered from gout.

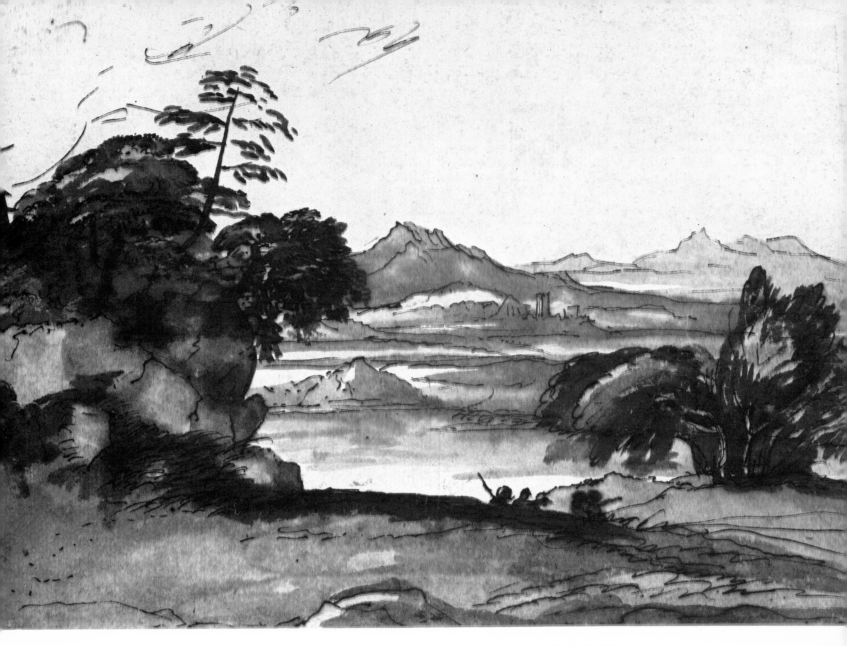

37. Landscape (1635-1640)
Pen, brown wash

British Museum, London

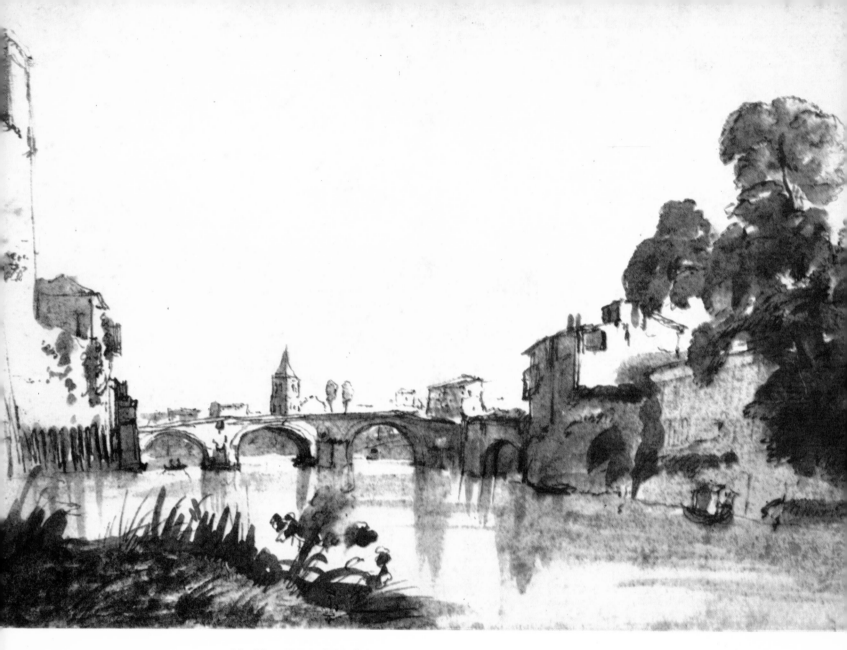

38. River View (1630-1635)
Pen, brown wash

Musée Condé, Chantilly

Sandrart has left a valuable note on the work of those early years: "He found me painting from life and saw that I painted many works from nature itself, making nothing from imagination." What role did Sandrart play in persuading Claude to work from nature? No doubt his company—and that of other painters—was an inducement to make expeditions into the Campagna. But we should not forget that drawing from nature was common at this time and that when Sandrart published his biography in 1675 he may have wanted to claim credit for having contributed to the training of so famous a painter. He goes on to say: "But while I was only looking for good rocks, trunks, trees, cascades, buildings, and ruins, which were great and suited me as fillers for history paintings, he on the other hand only painted, on a small scale, the view from the middle to the greatest distance, fading away towards the horizon and the sky."

This observation of Sandrart's is very valuable. It corroborates the tradition, mentioned by Baldinucci, that Claude's nickname among his Flemish friends was *Orizzonte*, or "Horizon." It confirms what we see in his drawings. The picturesque element is neglected in favor of subtle, almost musical modulations, a constantly renewed dialogue between earth and sky, forms and light. This dialogue has not always been properly appreciated. Pierre Jean Mariette, an eighteenth-century connoisseur, had this to say about Claude's drawings: "Of all the landscapists, Claude Lorrain put most air and freshness into his landscapes. This is where he excelled, for he was not happy in his choice of forms or of sites, which seem too uniform and repetitious in his compositions."

Let us make a quick inventory. The most frequent subject is trees. Sometimes the tree is seen in close-up, outlined against the light before a bright background (*Fig. 2*). Its crest is rounded, its transparent shade leads the eye into the mysteries of the undergrowth. This dome of coolness is a refuge from the violent brightness of the plain. Most often what caught Claude's eye was a clump of trees grouped together (*Fig. 47*). Here the lighting is more varied; the low branches cast their rippling shade in large washes at the lower edge of the page, while the trembling, light-drenched leaves at the top of the tree blend with the brightness of the sky. In the pencil study in Figure 21 the dancing rhythms of trunks and branches lead the eye in an oblique sweep toward the distance, where the foliage dissolves in mist.

Undergrowth is treated with the utmost variety. It inspires close studies of ivy-covered tree trunks intertwined in sinuous arabesques (*Fig. 20*). Their expressive silhouettes, opposed along emphatic diagonals, tower above the rushing stream. Seen from a greater distance, these tree trunks lend themselves to the study of light caught, as it were, in a series of screens *(Fig. 5)*. At the edge of the copse they firmly frame a distant view, revealing what Sandrart meant when he spoke of "the view from the middle to the greatest distance." *(Fig. 23, 16.)*

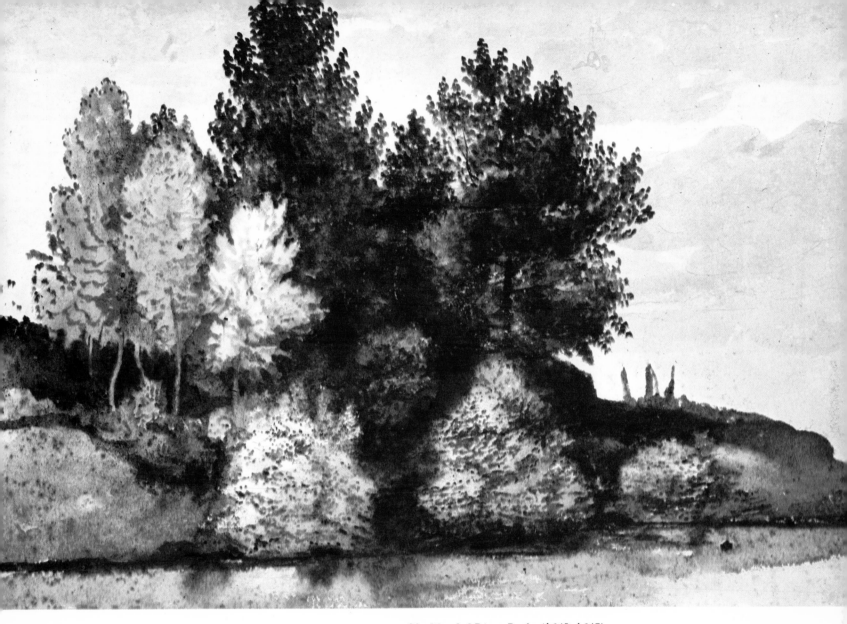

39. Wooded River Banks (1640-1645)
   Chalk, brown wash

   Teyler Museum, Haarlem

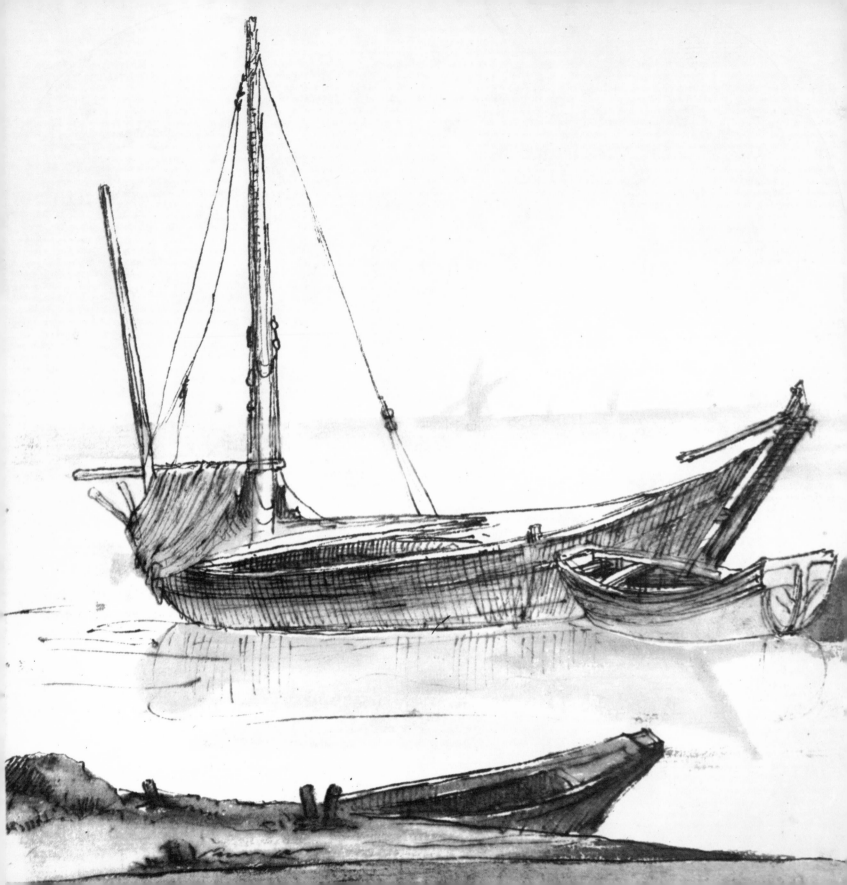

# Light of "Background Worlds"

It is in fact in the rendering of distances that Claude Lorrain excels. He foreground with vigorous washes, relying on blank white paper to convey the distant brightness ig. *19)*. He closed one side of the composition with a characteristic rock silhouette, leading the eye diagonally toward the undulating ridge of hills in the distance *(Figs. 41, 37)*. His desire to punctuate space with vigorous rhythmic accents sometimes led him to use remarkably bold devices: a few touches of wash, a few pen strokes scratched in to bring the shadows to life, and the whiteness of the paper itself are sufficient to suggest the dazzling light at the edge of a wood *(Fig. 36)*.

These drawings, which might be called suggestive rather than descriptive, are from the calm, limpid vision of the view of St. Peter's in Figure 30. Here a rustic character the panorama of the Eternal City unrolling at his feet in the bright, warm morning light. The impression of draughtsmanship is mellowed by the softness of the wash. What a contrast with the *View from Monte Mario (Fig. 29)* whose powerful tectonic structure recalls Cézanne! There are no lines. Space is created by the juxtaposition of large patches of wash that diminish in area and intensity toward the hori-

40. Boats (c. 1640)

Pen, brown and gray washes

Teyler Museum, Haarlem

zon.  The strongest contrasts are in the foreground, where the Tiber mirrors the brilliant white light.

Claude's pen and brush were attracted by other motifs too: rocks, torrents, grottoes, human figures, and animals.  There is no need to enumerate them; his art is not the sum of its parts.  Every drawing yields a clue to the secret of their charm, the mystery of their power.  The secret is the light.  Claude was less sensitive to objects, as such, than to the relationships between them, and to relate them he relied principally on light.  Even his contemporaries recognized this.  Sandrart wrote: "The sun plays over the grounds in all parts and lights up the grass, bushes, and trees almost as in life, showing everything perfectly in natural light and shadow, including the reflection, so that the distance of each object can be, as it were, measured in proportion and found correct, as in life itself."

What effects did Claude derive from light?  One constantly-used device strikes us immediately: the *contre-jour* effect.  Light never strikes the motif directly; the subject is never seen highlighted against a dark background.  It stands out against the light and against an ever-receding background, so that the light, emanating from the depths of the horizon, leads the eye in a mysterious sweep into the infinity of the sky.  These ever receding backgrounds of Claude's might be called "background worlds," evocative of hallucinations of all kinds.

His favorite way of initiating this sweep of the eye is by means of "screens" or planes :  A dark mass is set against a light ground, which is in turn set against a dark one, and so on right up to the horizon.  This technique had been common since the sixteenth century, Poussin used it too.  Claude, however, enriched it by a sort of oblique movement of the light along diagonal axes balanced by opposing diagonals.  The eye follows this luminous movement, whose rhythm is stressed by vigorous accents here and there.  The light is never focused on the center of the landscape.  In *Landscape (Fig. 20)* it casts on the foliage patches of brightness which balance the unevennesses in the ground, the changing clouds, and the shadows.  The trees dissolve in this unstable light.  Pools of light crowd into the drawing, creating an impression of trembling leaves and flickering shadows.  This extraordinary page is remarkably modern in feeling.

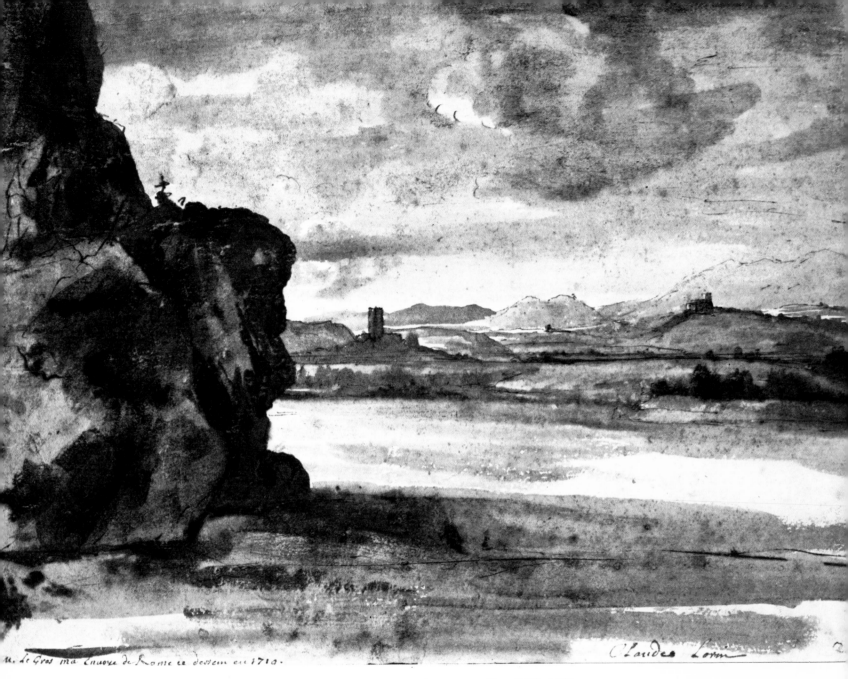

M. le Gros m'a envoié de Rome ce dessein en 1710.

Claudio Lorin

**41.** Tiber Valley (1635-1640)
Pen, brown and blackish washes

Albertina, Vienna

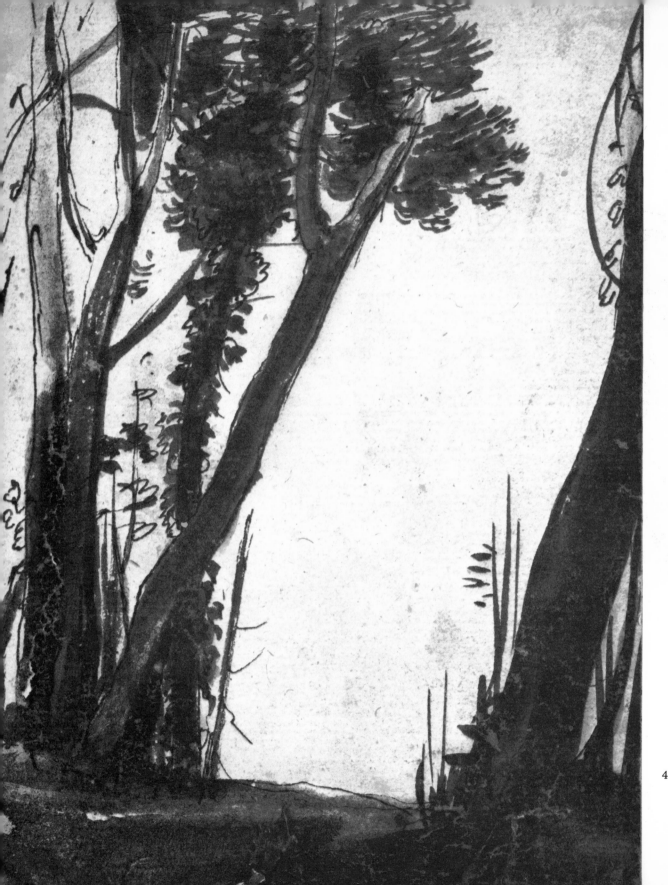

42. Trees (c. 1630)
Chalk, light gray wash

British Museum, London

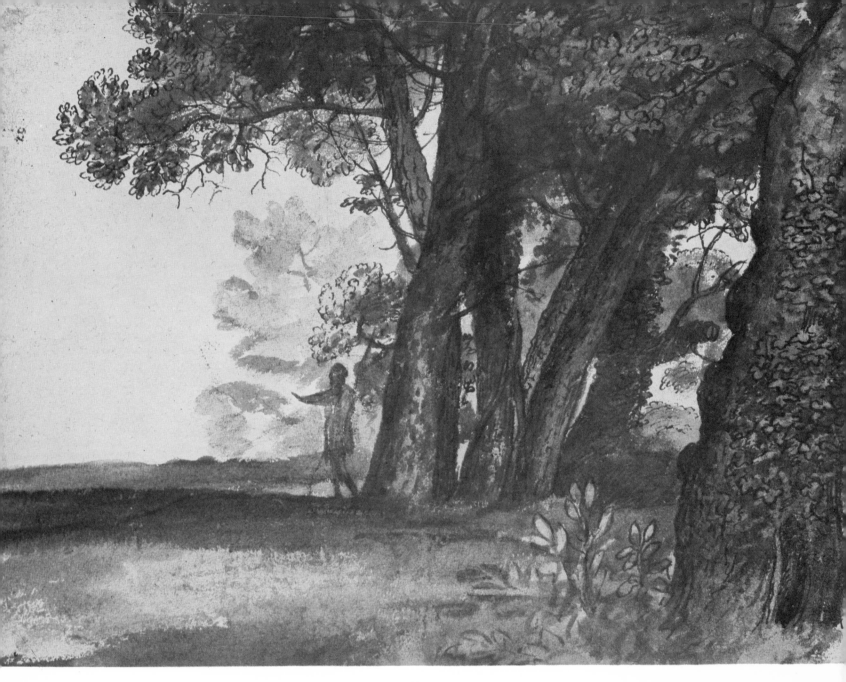

43. View with Trees (c. 1640)
Blue paper, chalk, pen, and brown wash

British Museum, London

# Dream Geometry

Yet countless other drawings by Claude Lorrain seem to show just the opposite effect: rigorous geometrical construction. We find evidence of it in the squaring of the drawings executed as preparatory sketches for painted canvases. The whole surface of *Harbor Scene (Fig. 52)*, for example, is crisscrossed with diagonal lines forming diamonds, which reveal the geometrical interrelationship of the masses. The architectural group on the left is counterbalanced by the vigorous silhouette of the ship at the right. The center is occupied in the distance by a tower and in the foreground by a group of people. They fit into a diamond whose area is half that of the architectural mass. The patch of open sky above them is equal in area to the ground they are standing on. The horizon is visible only in the center of the composition, where the harbor opens on the sea, at about two-thirds of the height of the drawing. We may note that this ratio of one to two is very close to the Pythagorean Golden Section which has always inspired geometricians of the dream world.

Yet this geometrical structure, this rigorous discipline, does not reduce the scene to a skeleton. If we eliminate the grid *(Fig. 53)*, other infinitely subtler relationships emerge which the crisscross framework had obscured. In the oblique movement we have already observed, the light slips behind the human figures so that they stand out against it. It leaves the ship in the foreground in the shade, skims across the tower, then shows up the palace façade in a blaze of white. The sky continues this dialogue in its contrasting clouds, which echo the lights and shades of the foreground. This dual reading to which Claude Lorrain's drawings lend themselves may well explain why he has been appreciated by all schools, even the most theoretically antagonistic.

Balance of parts and variety of rhythms—these are the essentials of Claude's style, both as painter and draughts man. Finding the right relationship between a leaf and a branch and properly balancing a pair of paintings are two aspects of the same fundamental concern. Only the technique is different. In one case the part is visually enriched through all kinds of devices; in the other a diagrammatic indication of the overall balance of the composition is all that is needed. The study reproduced in Figure 34 illustrates this gift of abstraction, this talent for generalization. The page is divided in four by strokes of the pen. In quick calligraphic lines Claude blocked in the tree masses, the background view, suggested the buildings. This is an embryo of the pairs for which he is famous. It gives us an idea of the amount of work required to convert these quick sketches into finished paintings and to integrate innumerable new details into the original composition.

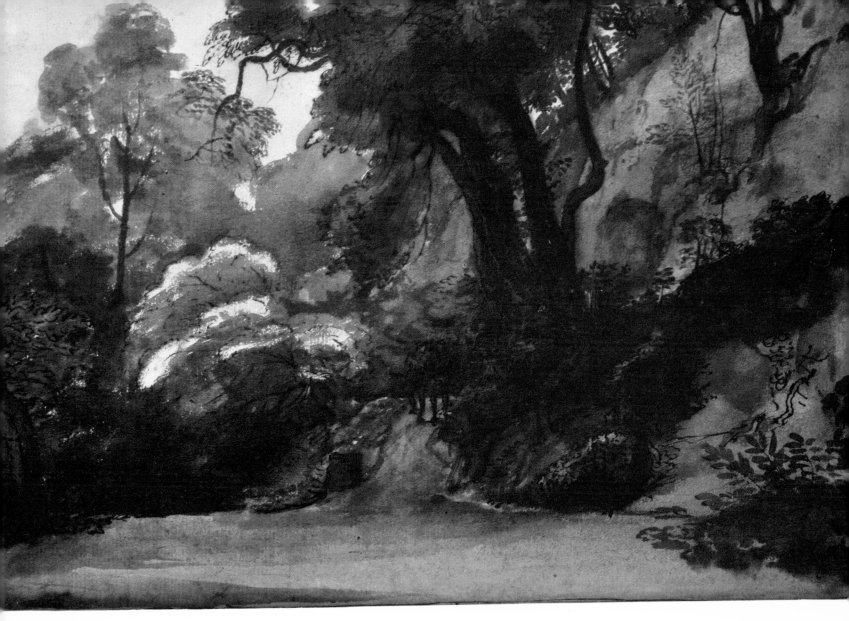

44. View in a Forest (1640-1645)
   Chalk and brown wash

   Gabinetto Nazionale delle Stampe, Rome

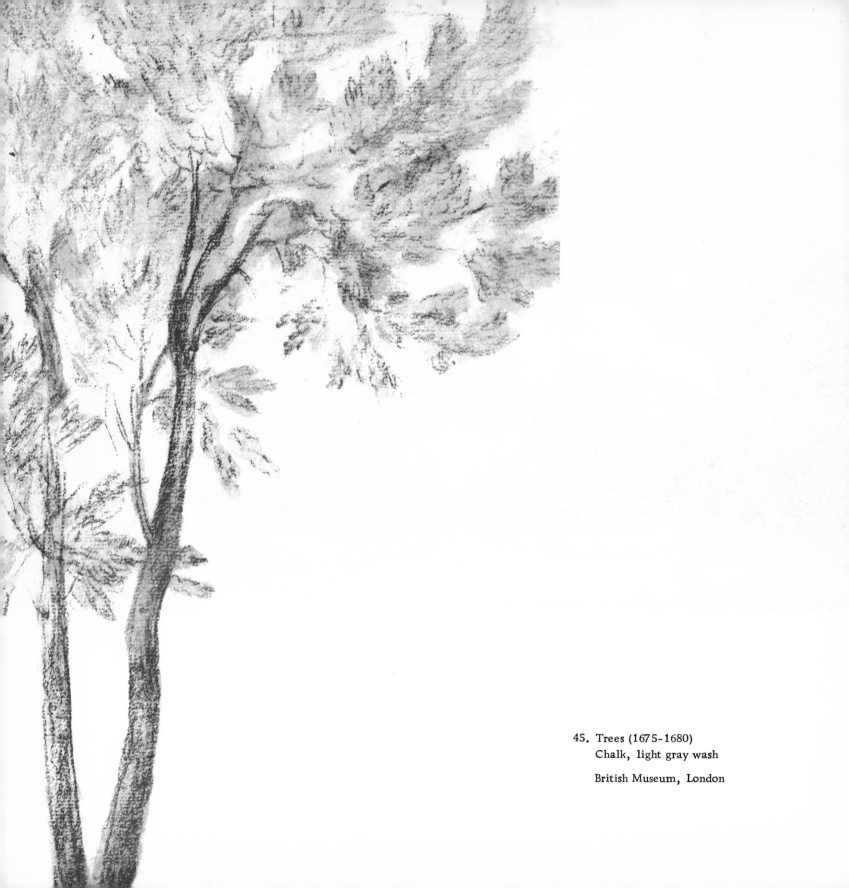

45. Trees (1675-1680)
   Chalk, light gray wash

   British Museum, London

**46.** Pastoral Landscape (c. 1645)
Black chalk, pen, and brown wash

Louvre, Paris

What about color? Claude owes his fame to his blue mornings, golden noontimes, and pink sunsets. Is it not unfair to expect a mere drawing to render the totality of an art in which color plays such an important role? Surprising as it may seem, Claude's drawings never entirely lack color, although, as we have mentioned, the technical procedures he used are very simple. Like his contemporaries, he used bister washes in most of his drawings. This warm color, which ranges from deep brown to the most delicate beige, blends wonderfully with the tones of the paper. This is the essential secret of wash: being completely transparent, it interacts with the paper, bringing out its whiteness or pastel tonalities. Claude sometimes used tinted papers, especially blue, and this produced a strangely mysterious mood in some of his drawings *(Fig. 48)*. Sometimes the background of a landscape or a sky is suffused with a beige wash against which delicate foliage is outlined. The pinkish tone of the background helps to create the illusion of a soft, enveloping light *(Fig. 15)*.

Claude is a master at suggesting the full range of the palette through the use of two predominant tones: bister for the warm tones and India ink or pencil for the cold ones. Supplemented by the whiteness of the paper and accented with touches of gouache, these can produce marvelously subtle and differentiated color effects. In the *Landscape (Fig. 20)*, for example, there is everywhere a feeling of color, although in fact it is limited to the interaction of these warm and cold tones. Drawing can be a wonderful instrument in the hands of a great artist. Claude's graphic work reveals all the resources of his large paintings on a more intimate scale, yet with no loss of intensity.

The drawings present, no less strikingly than the paintings, brilliant visions of a world of calm and beauty where the fleeting glow of a rising or sinking sun creates a harmonious setting for the legendary past. Indeed, they have a special charm of their own because they have never been subjected to the unfortunate cleaning and restoration that have impaired the incomparable luminosity of many of Claude's canvases. They look as fresh as when they were first made—sometimes even fresher, for the passage of three hundred years has stripped away all the intellectual, nonpictorial imperatives of the century that produced them. They reveal the mainsprings of Claude's art and shed a new light on the history of painting since the seventeenth century.

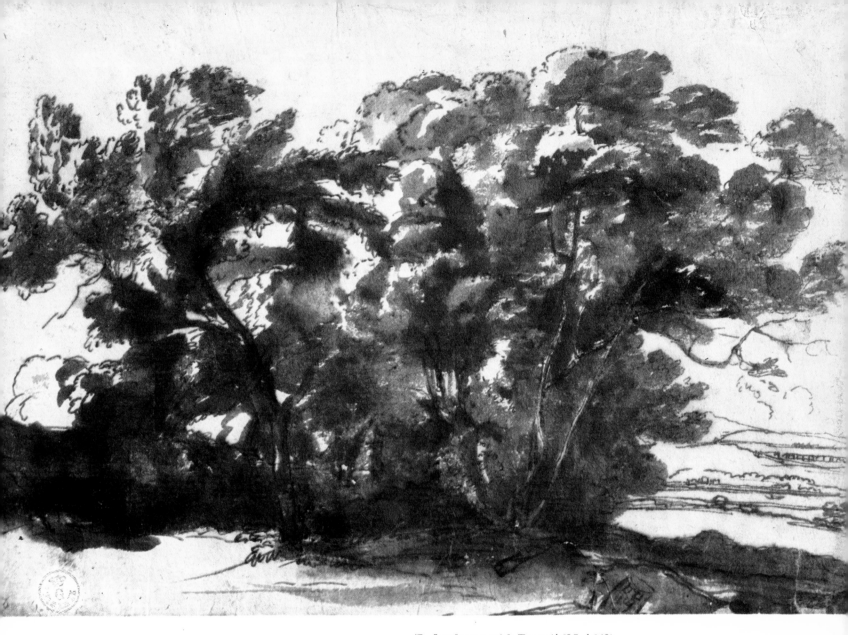

**47.** Landscape with Trees (1635-1640)
Pen, brown wash

Uffizi, Florence

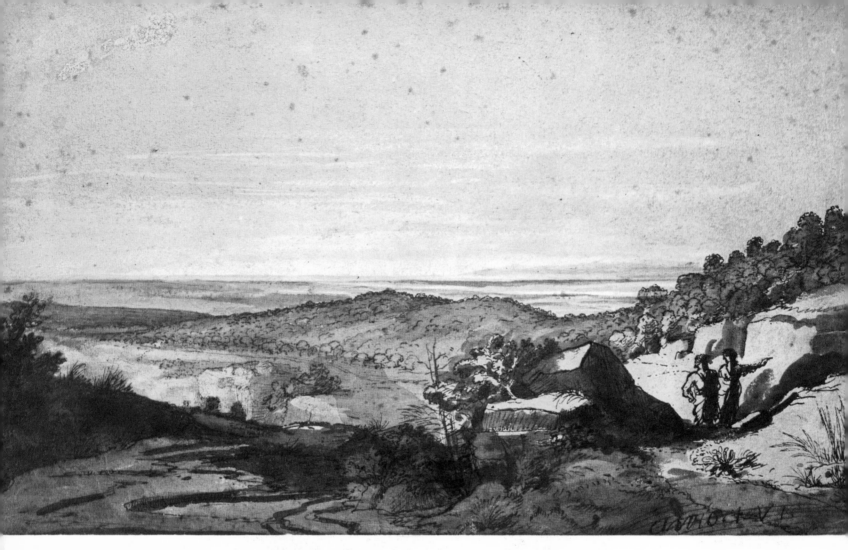

48. Landscape (1660-1665)
Blue paper, pen, and brown wash

Teyler Museum, Haarlem

# The Heritage of Claude Lorrain

Like Claude Lorrain's legendary heroes, generations of artists followed him in embarking for the unknown shores of Italy. Dazzled by the light in Claude's paintings, these Northerners hoped that they too would find on Roman soil man's eternal confrontation with his own history—with all History—in a wordless dialogue. They were seeking the splendor of antiquity combined with the splendor of nature. For centuries, Rome, for them the mother of history, and Italy, the bestower of beauty, had represented the realization of an ancient dream, of the desire every man cherishes in his inmost heart: to rediscover the sources of his own culture. Claude seems to have made the Roman Campagna artistically productive. Hubert Robert followed in his footsteps. Corot tried to penetrate the mystery of its light. Eighteenth- (and nineteenth)- century painters turned to its sites to learn what they had to teach, as Claude Lorrain had done in his time.

Is it not strange that this simple man should have sensed the deepest aspirations of his contemporaries? Is it not even stranger that it should have coincided exactly with the aspirations of the following centuries, of Classicism and Romanticism, and even with that of our own time? Claude's art is still fraught with myth. In the depths of modern man's unconscious, his paintings evoke the atmosphere of a lost paradise, a nostalgia for a golden age, now gone forever, when man, at peace with himself and his fellows, contemplated his own image before the beauties of eternal nature. Claude Lorrain succeeded in suggesting this secret harmony of man, nature, and culture on which the idea of classical humanism rests.

His works suggest the call of a previous incarnation such as any of us might have known. Baudelaire might almost have had one of Claude's *Seaports* in mind when he wrote in *La Vie Antérieure:*

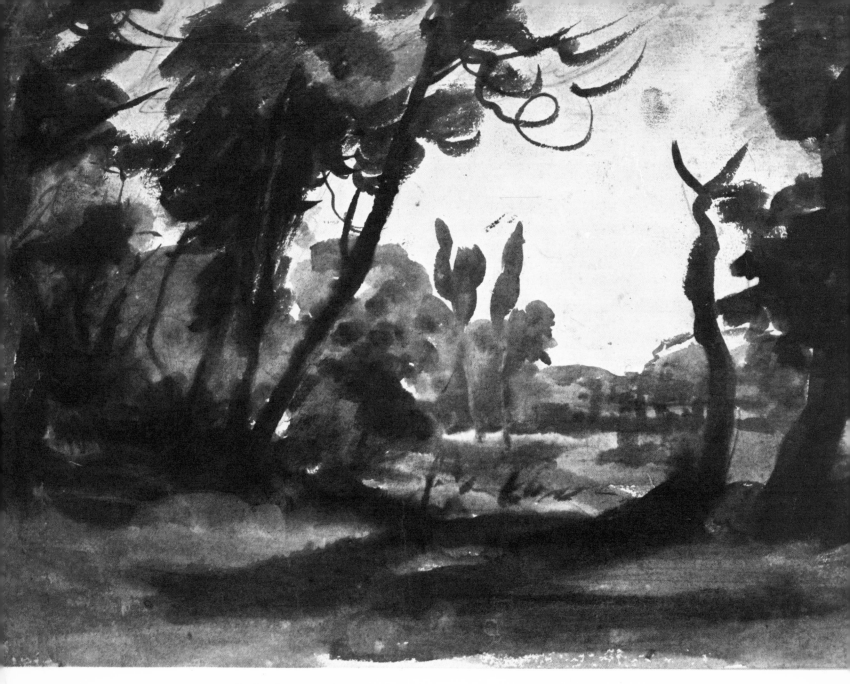

49. Landscape (c. 1635)
Chalk, brown wash

British Museum, London

*J'ai longtemps habité sous de vastes portiques*
*Que les soleils marins teignaient de mille feux*
*Et que leurs grands piliers droits et majestueux*
*Rendaient pareils, le soir, aux grottes basaltiques.*

For a long time I lived under great porticoes,
Which marine suns would emblazon with a thousand fires,
And which their great pillars, standing tall and majestic,
Turned at evening into caves of basalt.

Yet if we set aside these romantic visions and look at Claude Lorrain strictly in his seventeenth-century context, he may well appear as the incarnation of what historians commonly call the classical ideal. He answered its canon, as his drawings show. Like Racine, he wanted "to do easy things in a difficult way," to gain maximum effect from minimum means. Like the author of *Bérénice*, he rejected the picturesque and all Baroque truculence of language. His plastic vocabulary shows the same self-discipline. For both Racine and Claude this is a matter of restraint rather than poverty. Both have the same equilibrium and clarity. Claude's foliage sways to an Alexandrine rhythm.

But if we stop here, even in the name of historical truth, we shall never understand the later destiny of Claude's work. To ignore its progeny and its fruitfulness throughout the ages is to sterilize it. If Claude excited Turner and through him brought Impressionism to life, it was certainly not because of his classical message or his rigorous geometrical structure, but rather through his unique vision, his visual and emotional impact, his characteristic originality, none of which can be properly defined in terms of conditioning or historical substructures. Conversely, to see him only through the eyes of twentieth-century man, in the light of some kind of aestheticism beyond formulation, is also to limit him. And indeed this has been his fate—the price he paid for fame.

The age of Impressionism reduced him to colorful dust. Neoclassicism had eyes for nothing but his skeleton; the Rococo for nothing but the propitious shade of his bosky woods. Modern lyrical abstractionists and figural painters are interested only in his graphic aspect, his handwriting, while the geometrical abstractionists approach him with ruler and compass. Anyone with anything to gain by it lays claim to him. Indeed, Claude Lorrain's greatness, his universality, does not lie in his appeal to this or that school, however contemporary, but in being able to satisfy them all, to offer each of them a valid truth.

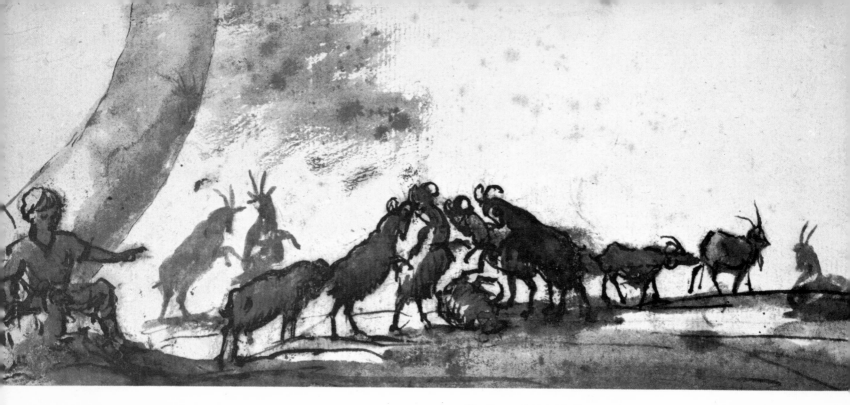

50. Goats (1645-1650)
Pen, brown wash

British Museum, London

This is what has earned the master his privileged place. The ultimate lesson he has to teach us is, like his art, a complex one, being historical, plastic, and logical all at once. In fact it requires us to adopt a new logic. If we wish to grasp Claude Lorrain in his totality, we must stop trying to resolve the contradictions. Not only must we accept them: we must even try to reconcile the antitheses. He represents discipline in the evanescent, line in light, color within drawing, fantasy within mathematical precision, the romanticism of classicism, no less than the geometry of dreams. This makes him more than contemporary: it makes him indispensable to us today. He proves that great art eludes all labels, all categories; he restores it to its timeless context. More plainly than anyone else, he shows that a creative artist of this stature can never be seen in the definitive light of eternity—*tel qu'en lui-même enfin l'Eternité le change*, as Mallarmé said of Poe. Eternity for Claude Lorrain means a perpetually changing image. The same may be said of him as of his paintings: He is the dialogue between the close and the distant; he is mystery in the full light of day.

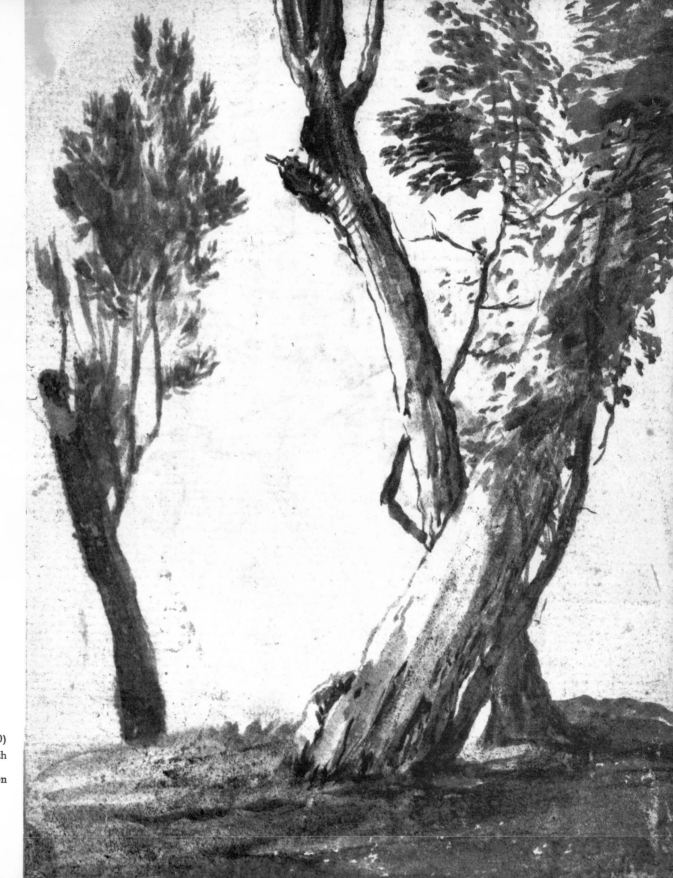

51. Trees (c. 1630)
Brown wash

British Museum, London

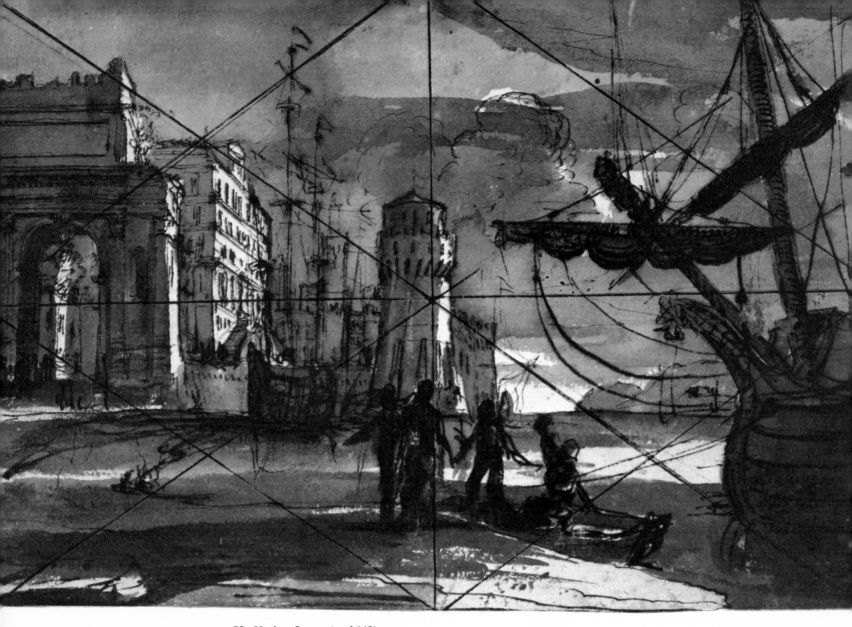

52. Harbor Scene (c. 1640)
   Pen, brown wash, squared with diagonals in pen

British Museum, London

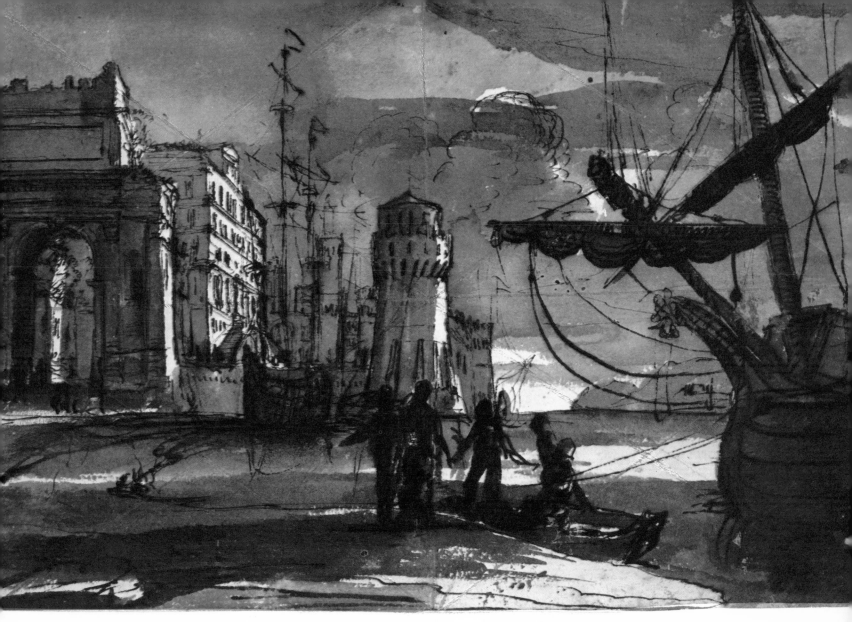

53. The same as Figure 52
without the diagonals

54. Pastoral Landscape (1645)
Brown wash, pen, and chalk

Pierpont Morgan Library, New York